Thirty
WORKS OF Art
Every student SHOULD KNOW

ANDREW JAY SVEDLOW , PH.D.

Kendall Hunt
publishing company

Cover image © Shutterstock, Inc.

Kendall Hunt
p u b l i s h i n g c o m p a n y

www.kendallhunt.com
Send all inquiries to:
4050 Westmark Drive
Dubuque, IA 52004-1840

Copyright © 2015 by Kendall Hunt Publishing Company

ISBN 978-1-4652-5705-5

Printed in the United States of America

Dedication..

To the many art appreciation, art history, art education, arts administration, museum studies, and studio art students that I have learned from over the course of my career as an educator.

Contents

Introduction ... vii

Chapter 1 Lascaux: The Beginnings ... 1

Chapter 2 The Great Pyramid of Giza: The Monumental 5

Chapter 3 Discobolus by Myron: The Classical Greek World .. 11

Chapter 4 Pompeii: The Roman Empire 15

Chapter 5 The Terracotta Warriors: The Great Wall
and the Qin Dynasty ... 19

Chapter 6 The Good Shepherd: The Dawn of Christian Art ... 23

Chapter 7 The Great Buddha of Kamakura: Buddhist Art ... 29

Chapter 8 Persian Miniatures: The Art of Islam 35

Chapter 9 The Book of Kells: The Middle Ages 39

Chapter 10 Chartres Cathedral: The Gothic World 43

Chapter 11 The Lamentation of Christ by Giotto: The Start of the Renaissance47

Chapter 12 Mona Lisa by Leonardo da Vinci: The Genius of the Renaissance51

Chapter 13 The Sistine Chapel by Michelangelo: The Height of the Renaissance55

Chapter 14 Indian Sculpture: The Hindu World...59

Chapter 15 Aztec Sculpture: The New World ..63

Chapter 16 The Great Wave of Kanagawa by Hokusai ...67

Chapter 17 Dogon Art...71

Chapter 18 El Greco: The Age of the Inquisition ..75

Chapter 19 Self Portrait by Rembrandt: The Dawn of the Modern Era79

Chapter 20 Liberty Leading the People: The Age of Enlightenment..83

Chapter 21 The Oath of the Horatii by Jacques-Louis David, 1784: Neo-Classicism85

Chapter 22 The 3rd of May 1808, painted by Goya in 1814: Romanticism89

Chapter 23 Water Lilies by Claude Monet: Impressionism ...93

Chapter 24 Self Portrait by Vincent Van Gogh: Post Impressionism97

Chapter 25 Les Demoiselles D'Avignon by Pablo Picasso: Cubism101

Chapter 26 Georgia O'Keeffe: An American Original ..105

Chapter 27 Kathe Kollwitz: The World at War..109

Chapter 28 Lavender Mist, 1950 by Jackson Pollock: Modern Art113

Chapter 29 Andy Warhol's Campbell Soup Can: Pop Art ..117

Chapter 30 Kara Walker: The Art of Today...121

Conclusions ..125

Appreciations...127

Resources..129

About the Author ...139

Index...141

Introduction

This text is an introduction to the world of the visual arts. It is hoped that after taking advantage of the thirty chapters in this book that readers will be able to look more closely at and find meaning and significance in the world around them through the visual arts. They will become familiar with a broad range of subject matter, style, and medium, as well as with the historical and cultural contexts in which the visual arts have been made. Primarily a text book, it is anticipated that readers will also actively participate in the suggested endeavors scattered throughout the book.

It is the aspiration of the author that users of this text will develop and share in some of the following:

- An understanding of the materials and methods of the visual arts
- A growing knowledge of the people who have and do make art and the historical and cultural contexts in which they have and do create art
- The diversity of themes and traditions within the visual arts
- The significance of the visual arts in the life of the reader

What is important about Art?

This book will provide you with the chance to contemplate the significance of art and the meaning it carries.

What are some of the original source materials of Art?

Selections of thirty original works of art are used as means to better understand the context of art and aesthetics.

What is the history and the implications of the history of Art?

Thematic and global reviews of art, through these thirty paradigms, are also expected to lead to a better understanding of the art of today.

Many art appreciation text books are based on the concept of "acquisition of style." This means that readers gain the ability to recognize the "style" of individual artists, individual art movements, or periods of art by diligent study of exemplars of those styles, schools, or periods of art. In this volume, readers will not only have the opportunity to encounter art through reproductions but, they will also be encountering opportunities to muse about the complexity of the global traditions of the visual arts.

Why these thirty works of art? Of course, through the complex and enormous history of the visual world across time and place there are a seemingly unlimited number of choices of art and architecture to examine. However, through these thirty archetypes we are able to grasp a depth of meaning that a breadth approach to the subject would not allow us to do in such a short expanse of text. These thirty models will elucidate and help us to discover the captivating story that is the visual arts.

The manuscript will take us on a journey from the earliest products of the human imagination through the long and fascinating history of magnificent artistic works that span the globe and reach into the twenty first century. While some of these superlative creative works of art will feel familiar and others may seem foreign, this text will help unfold the tale of the visual arts in a new, distinct, and vivid account that will optimistically be the first of many steps you take into the world of the visual arts.

What is Art Appreciation?

Throughout time, philosophers, artists, art critics, and educators have inquired into the value and meaning of art. In many cases, these analyses have been devoted to communicating the reality of beauty as it is present in places across time and cultures and in explicating what should be or ought to be considered the ideal of beauty. At times, these discussions center on the creation of a specific vocabulary to share ideas about beauty and, sometimes they look to the values of a time and place as they are manifested in the objects and ideas of material culture that we have come to define and accept as the visual arts. It is this former endeavor that we have set before us in exploring these thirty works of art. The challenge is not so much to define their specific meaning as it is to discover what values of their time and place are being manifested in their existence and then how that reality or context sets the stage for us to further understand the significance

of these creative works in our individual and collective lives today. This might very well be the way we come to appreciate these and other aspects of the human condition as opposed to merely making superficial judgments about their presence as being beautiful or not. Therefore, we might say that this act of working toward finding the contextual meaning of these great works of art, as well as laboring to unfold their significance in our lives, is the act of appreciating.

What informs our looking at these works of art?

It seems that some of our first inclinations when approaching works of art, whether in a museum, someone's home, a public building or park or plaza, or even virtually through reproductions, is to attempt, in our minds, to describe and make experiential connections with these objects or even the monumental structures we might encounter in our lives. Common internal questions to ourselves might be what are the recognizable things in this work of art that I actually understand and find familiar? As an example, Hokusai's great and widely reproduced woodblock print, Great Wave at Kanagawa (See Chapter 16), certainly has quite familiar imagery: water, white capped waves, the presence of a mountain in the background, and people in long boats.

But what might inform our looking even more at such an object? A visual analysis of the print, such as the colors, the forms, the use of line and other principles and elements of design might help us appreciate the forceful dynamic that the artist presents us with. Trying to find the appropriate vocabulary to share your description of this work might lead you to a more thoughtful and deeper sense of this work of art. Contemplating the action described by the artwork and the relationship of those actions to your experiences might lead to a more informed viewing of the object. Perhaps delving into the cultural context and symbolism of this mid-nineteenth century Japanese print might also give the viewer a better-rounded and balanced sense of the meaning of the work, hence forth making the viewing of the work even more emotionally and intellectually satisfying.

The more questions the reader asks of each of the works profiled in this book, the more they will expand their depth of knowledge and understanding of the work of art. This act of questioning will in due time inform the way you describe, interpret, and appreciate the importance of works of art that one sees and approaches in the future.

This text will examine and present each of the thirty works of art chosen in four major categories. One, each work will be analyzed visually or what may be referred to as the looking portion of the inquiry. Second, the works will be discussed and considered from their historical and cultural context. Third, readers will be provided with opportunities to appraise the artworks through suggested creative projects and, fourth, read-

ers will be further encouraged to discover a deeper magnitude of the art in their lives through taking advantage of co-creation projects as listed in some of the chapters.

Dovetailing with these four approaches, four more interpretative lenses are applied in each section to further elucidate the meaning and substance of each work of art. Firstly, the objects will be described and their physical properties and sometimes their means of production will be put forward. Secondly, the biographies of individuals implicitly or explicitly involved in the creation of these works of art will be detailed. Thirdly, the societal institutions, economic systems, and the rituals and practices of the cultural context of the work of art will be put forward. Fourthly, the transcendent meaning or metaphorical presence or the poetic power of each art work will be elucidated.

Throughout this book you will notice the use of bce and ce as part of the dating system in the text. BCE stands for Before the Common Era and CE for Common Era.

Chapter 1
Lascaux: The Beginnings

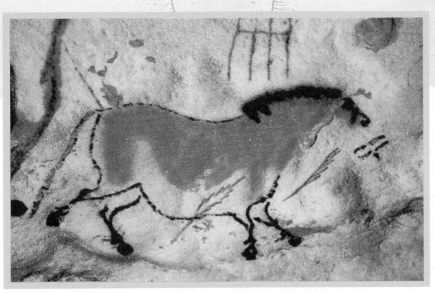

Lascaux Dordogne France

Human artistic activity can be traced as far as back as over 40,000 years ago. Evidence of this outburst of imagery is found in caves in Western Europe, in particular in Spain and France. Paintings and incisions into the rock still remain in these deep caves and they serve as witness to the impressive visionary capacity of the earliest of peoples. On the evolutionary timeline of our species, these works of ingenious resourcefulness mark the outset of humanity's capacity to be inspired and to inspire others.

Lascaux, a region located in southwestern France contains a striking number of caves containing Paleolithic art. The majority of the images found at Lascaux depict animals, such as horses, deer, bears, wolves, and bison. Sweeping dark outlines and earth toned pigments model the musculature of the beasts in action. The charismatic mega fauna appear to burst across the cave walls as if they are in pursuit or being pursued. Lascaux, not unique in the cave art of this early chapter in human history, also contains engraved images into the solid rock walls. Along with the paintings, these markings provide a vivid admittance into the complex creative inner life of these Paleolithic people.

Paleolithic, as used in discussing art history or art appreciation, usually refers to the time period of about 40,000 years ago and more formerly known as the Late Upper Paleolithic. This era of the Paleolithic continued until and through the end of the Pleistocene ice age which is usually calculated as ending about 10,000 years ago.

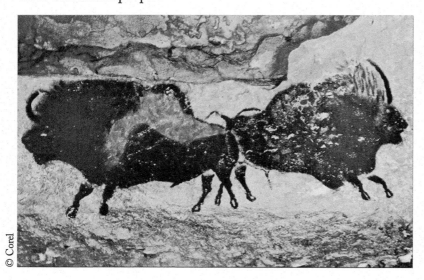
© Corel

Lascaux Dordogne France

The pigments used in these chambers came from the natural plants and minerals found in the region of Lascaux and the pigments may have been blown onto the cave surface through a pipe like tool or off the hands of the artists themselves or, they may have even been blown directly onto the walls from the mouths of these early experimental artists. These Paleolithic artists have been succeeded by legions of creative individuals and cultures. A mere 20,000 years ago, people were situated across the globe painting and sculpting and creating habitats that would last to our present day. Some in tombs, such as in Egypt, others through rock art such as found in Aboriginal art in Australia, and other less perishable artifacts in bone and stone found on every continent but Antarctica.

Lascaux is perhaps the most famous of the Paleolithic cave art sites and was discovered in the Vezere Valley of the Dordogne region of France and is thought to be at least 20,000 years old. In 1940 the large caves that comprise the Lascaux network of caverns were detected.

Today, Lascaux is a UNESCO World Heritage Site and is considered one of the most important historic and artistic treasures in the world. Images of bulls and horses are predominant in the caves of Lascaux but, cattle, bison, and even a bird seemingly float across these caverns.

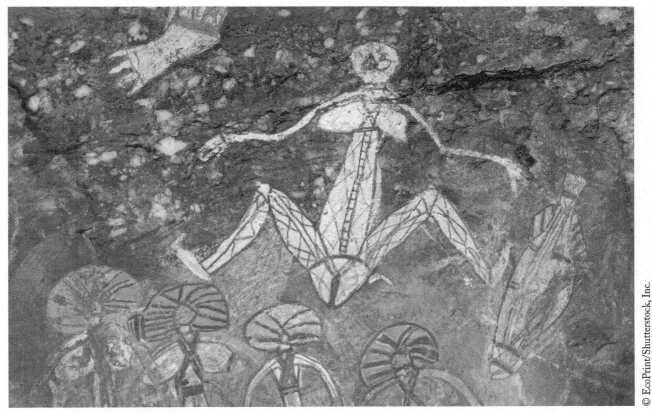

Aboriginal rock art (Namondjok) at Nourlangie, Kakadu National Park, Northern Territory, Australia

© EcoPrint/Shutterstock, Inc.

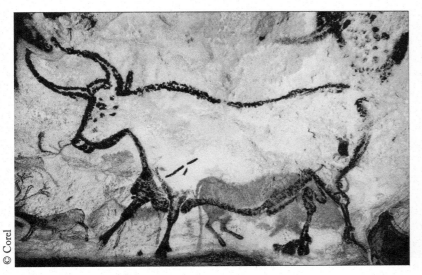

© Corel

Red Bull Lascaux Dordogne France

According to Article 1 of the General Conference of the United Nations Educational, Scientific and Cultural Organization meeting in Paris from 17 October to 21 November 1972 the following is to be recognized as the purpose for the designation of a World Heritage Site such as Lascaux: works of man or the combined works of nature and man, and areas including archaeological sites which are of outstanding universal value from the historical, aesthetic, ethnological or anthropological point of view.

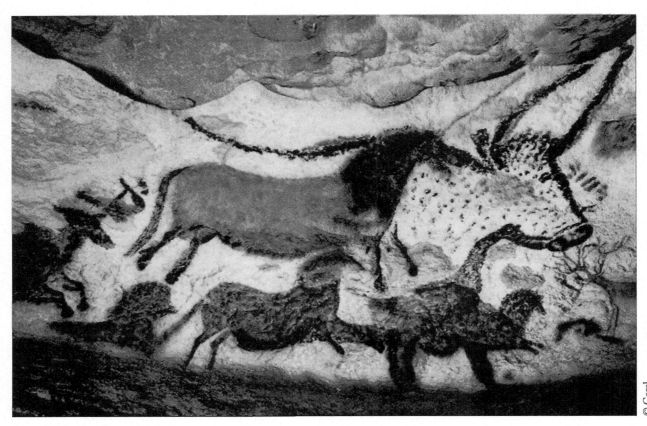

© Corel

Bison, Altamira Cave, Spain

A much earlier discovery in 1879 of another magnificent grotto full of Paleolithic cave art took place in Altamira, Spain. Unlike the cave paintings at Lascaux, the Altamira caves have depictions not just of animal life but of humans as well. The realistic depiction of animals twist and turn through the connected chambers of this cave complex. Bison seem to dominate the walls of the Altamira caves but also included in the panoply of animals there are images of human like masks and, quite remarkably, the outline of human hands impressed upon the cave walls.

Altamira, like Lascaux, is also a UNESCO World Heritage Site and one of the most valued places of illustrious art on the planet.

WRITING PROJECT .

It is, of course, impossible for us to know exactly why these images were produced in places such as Lascaux and Altamira. However, it may be instructive to think about the possible scenarios for the intentions of the creators of these glorious works of art. A creative writing project to accompany this discussion of Paleolithic cave art is to write a short story about the possible ritual or purely narrative purposes that such cave art may have been in service to.

Chapter 2
The Great Pyramid of Giza: The Monumental

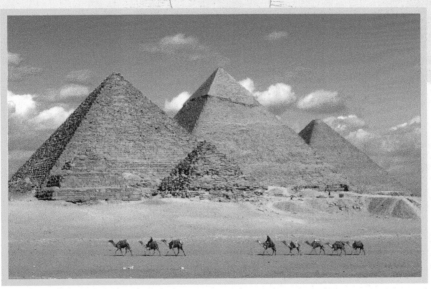

© Sculpies/Shutterstock, Inc.

O f the wonders of the world perhaps the Great Pyramid of Giza is one the most recognizable landmarks on the planet. Built as the tomb for the Egyptian pharaoh Khufu, the structure has three burial chambers. It was built approximately 4550 years ago and it is the largest pyramid built in ancient Egypt and one of three such structures that are located near El Giza outside of Cairo. Unlike many other Egyptian pyramids, Khufu's tomb has no hieroglyphics painted on or engraved into the pyramid's interior walls.

Khufu's Great Pyramid is constructed, primarily, of limestone blocks and is 756 feet long on each of its four sides and rises to a height of 450 feet. The two other pyramids standing elegantly in a row with the Great Pyramid of Khufu are the pyramids of the Pharaohs Menkaure and Khafre, Khufu's son. The ancient Egyptians believed the pharaohs to be living gods and in turn devoted much time and labor to construct elaborate tombs, such as the pyramids, to entomb their god kings. Buried with the pharaoh were untold riches and the accoutrements that the pharaoh would need for his eternity in the afterlife.

Egyptian hieroglyphics is a system of writing that is one of the most ancient in the world. The origin of Egyptian hieroglyphs is not known and there is no identifiable antecedent to the hieroglyphs found in tombs such as those at Giza. While there have been numerous conjectures as to the original purposes for the invention of hieroglyphs, such as for ritual or sacred purposes or for documenting important events, it may very well be that the intention was for economic and trade reasons. The deciphering of Egyptian hieroglyphs is now readily available because of the cracking of the code of the Rosetta Stone which was made in 196 bce and rediscovered in 1799 ce and decrypted in 1822 by Jean-Francois Champollion.

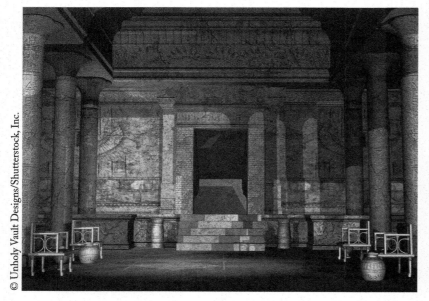

© Unholy Vault Designs/Shutterstock, Inc.

Egyptian Pyramid Interior

The mummy of the Pharaoh Khufu and the treasures buried with him are long gone and their whereabouts are certainly unknown. Khufu, also known by his Greek name Cheops, was the son of Sneferu and Queen Hetepheres I. There is very little information to be found about Khufu and the only known representation of the god king is a small ivory sculpture.

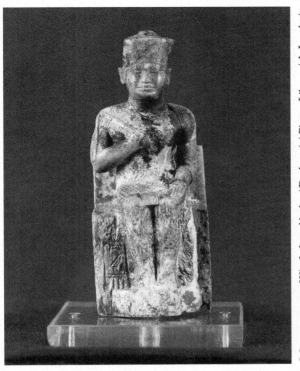

© Ivory statuette of Khufu from Abydos / De Agostini Picture Library / A. Jemolo / Bridgeman Images

© Corel

Khufu was a mere twenty years old when he came to take the throne and he began the design and construction of his pyramid very early on in his reign. The Great Pyramid at Giza was the first constructed on the site and took approximately 23 years to complete.

Of the eighty or so known pyramids in Egypt today, the three located at Giza are the most prominent and recognizable. The word pyramid is derived from the Greek word "pyramis" which translated into English as "wheat cake." The ancient Egyptian word for these tombs was "mer." The Great Pyramid is referred to colloquially as the "House of Eternity." The Great Pyramid of Khufu resides on the west bank of the Nile River. The four sides of the pyramid each face directly toward their cardinal orientation indicating the architect's desires to orient the structure in the four directions; east, west, south, north. The limestone for the pyramid's construction was

Queen Nefertiti ruled Egypt with her husband, Pharaoh Akhenaten from 1353 to 1336 bce and her legendary beauty was immortalized in this painted sandstone sculpture portrait bust which was discovered in 1913 by Ludwig Borchardt, a German archaeologist while he was excavating in the city of Amarna. In 1922, a British archaeologist, Howard Carter uncovered the tomb of King Tut and since that time there has been worldwide interest in the artifacts and life ways of ancient Egypt.

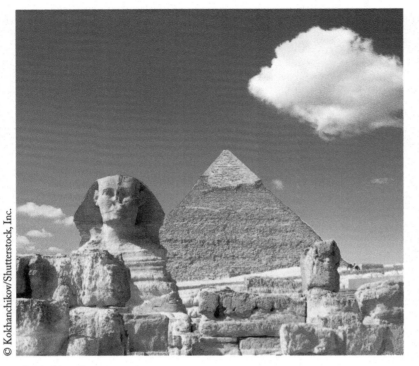

© Kokhanchikov/Shutterstock, Inc.

The Sphinx, Egypt

quarried not far from the site of the edifice. Most archaeologists believe that this pyramid's cap stone block of limestone, the top point of the pyramid, was sheathed in metal, perhaps gold or a mixture of gold and silver. The sides of the pyramid were also covered with a stronger and smoother white limestone quarried from across the Nile River from Giza. The pyramid as it stands today has little of the original exterior stone work that once enveloped the stepped masonry now visible.

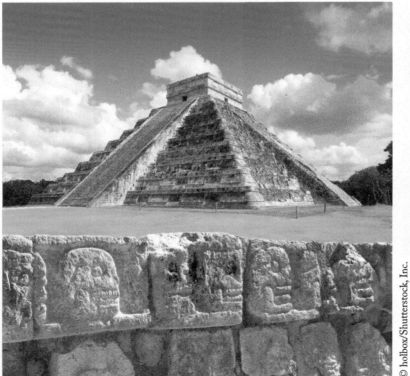

© holbox/Shutterstock, Inc.

Chichen Itza, Mexico

Monumental art, such as the Great Pyramids at Giza are found across the globe and represent both the engineering feats of ancient and modern cultures as well as the aspirations and values of those societies. Many such works of monumental art have become enduring symbols of the cultures that built them.

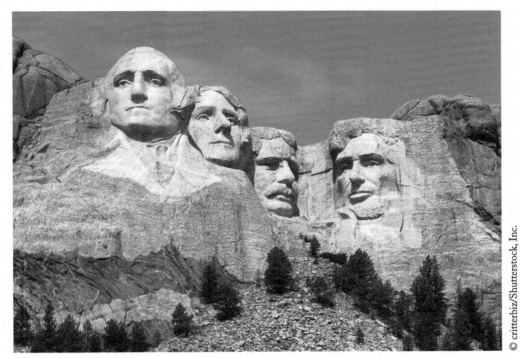

Mount Rushmore, South Dakota

© critterbiz/Shutterstock, Inc.

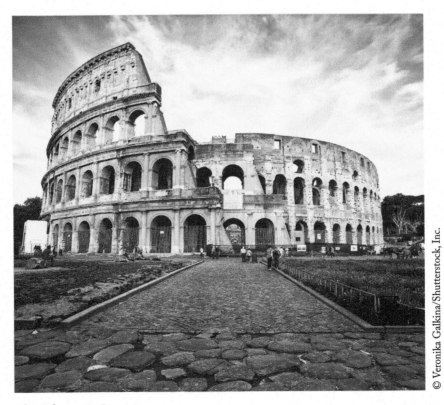

The Coliseum in Rome

© Veronika Galkina/Shutterstock, Inc.

STUDIO PROJECT

Working with found materials, construct a small pyramid that is a scale model of the Great Pyramid of Khufu. In presenting your completed pyramid, share the challenges that you had in creating such a structure and what techniques worked best to support the model from falling down. Think about the purposes of the Pyramids at Giza and relate how your pyramid manifests the world view of the ancient Egyptians. Complete a two-dimensional diagram of what you have intended for the interior of your pyramid and present that, as well, with your three-dimensional pyramid.

Chapter 3

Discobolus by Myron: The Classical Greek World

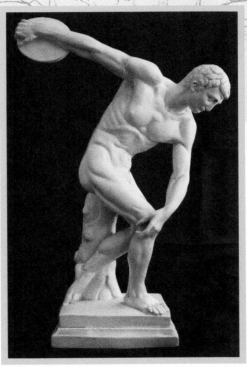

© Carmen Ruiz/Shutterstock, Inc.

The Discobolus or discus thrower that we see today at the British Museum in London is a Roman marble copy of the original Greek bronze sculpture created by the sculptor Myron who worked circa 450 bce. The Roman copy is from Emperor Hadrian's villa in Tivoli, Italy. As with many Roman copies of classical Greek sculpture, the Romans relied on an element such as the tree trunk in this marble sculpture to balance and hold up the human element. The original Greek sculptures contained no such devices or crutches to maintain the

erect posture of the sculpture. According to the British Museum, the head of the discus thrower in the original Greek sculpture, most likely, was looking upward toward the discus. Discobolus represents not just the classical Greek value for athleticism as manifested in the Olympic Games but, also the Greek ideals of dispassionate and rational behavior. The unemotional and detached look of the discus thrower is symbolic of the objective and unruffled logic of the highest ideals of the intellectual elites of the city states, such as Athens, that amassed wealth and power during the time period of Classical Greece, circa 500 – 300 bce.

After the Athenians defeated the Persians in 478-9 bce to maintain their city-state as a vital center for trade and intellectual and artistic productivity, they organized what was to become the Delian League. Originated on the island of Delos, hence the name Delian League, this loose confederacy of city-states was intended to protect the Greeks from the Persians but, the League itself devolved into warring postures between the city-states themselves and led to the Peloponnesian War and the eventual fracturing of the League. Athens quickly became, at this time, the wealthy center of the Greek empire and the nucleus for the development of Greek culture and philosophy.

The Acropolis, a high point within the city-state of Athens became the focal point of architectural activity and the site of the construction of numerous temples devoted to the patron goddess of the city-state, Athena. The Parthenon is the exemplar of Classical Greek architecture and this Doric temple manifests the Classical Greek sense of ideal proportions and ideal beauty. This marble edifice is festooned with numerous sculptures and decorative elements.

The Olympics may have started as early as 776 bce in the city of Olympia located on the island of Pelops. Most likely begun as a tribute to the Olympian gods, the ancient games continued for many centuries until the Roman Emperor Theodosius banned them in 393 ce. The discus, as seen in the sculpture by Myron, was originally made of stone in the ancient games and later of metals such as lead, bronze, or iron. The discus throw was part of the Pentathlon in the ancient games and included four other sports: two running races, jumping, and wrestling. The modern Olympics resumed in 1896 in Athens, Greece.

The idea of proportion or the ideal ratio between height, depth, and width or sometimes referred to as the Golden Ratio is represented by the Greek letter Phi. Both Pythagoras and Euclid, ancient Greek mathematicians, worked to calculate the golden ratio which may be simply viewed as a ratio of 1:618. Phidias, the Classical Greek sculptor used the golden ratio to create the statues on the Parthenon as an embodiment of this reasoned mathematical equation.

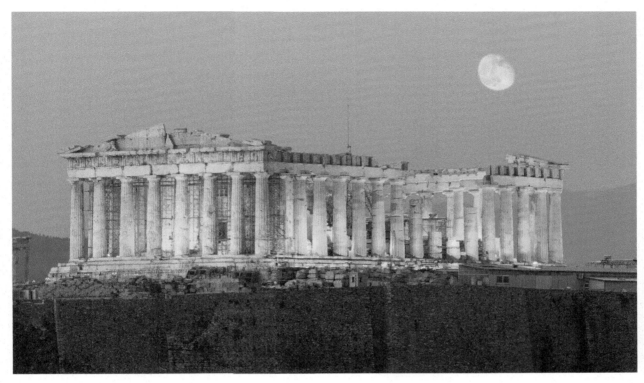

The Parthenon, Athens, Greece

The Classical Greek period included not just the construction of glorious temples but, also the development of finely turned and painted pottery vases, and free standing bronze sculptures, such as the original Discobolus. Architecturally, Greek temples may be divided into three styles: the Doric as exemplified by the Parthenon, the Ionic as manifested in the Temple of Athena Nike on the Acropolis and, the Corinthian as seen in the Temple of the Olympian Zeus in Athens.

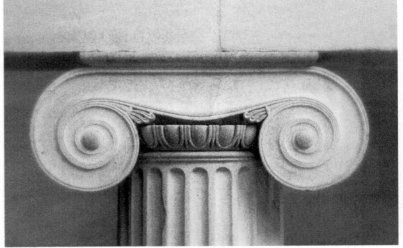

Ionic Style

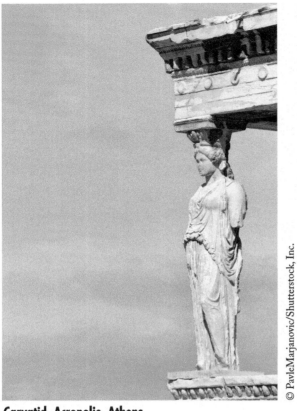

Caryatid, Acropolis, Athens

Myron of Eleutherae applied this sense of a harmonious and well-proportioned body in motion in the Discobolus. The sculpture embodies the ideal athlete: muscular, agile, focused, composed, and full of youthful vigor. Poised at the moment of release, the parts of the sculpture all function in unison, in splendid harmony. The Greek aesthetic ideal of harmony, balance, and correct proportions come together stunningly in Myron's masterpiece. The artist achieves a highly accomplished sense of realism which may have reached its pinnacle at this time in Greek art history.

RESEARCH PROJECT

Using internet and library resources, inquire into the Classical Greek period and, in particular the city-state of Athens and its political, economic, philosophical, and aesthetic values and ideas. Focusing on the art and architecture of the Acropolis, explain the use of the Golden Ratio and how the iconography of the Greek gods and Greek philosophical ideals are manifested in the temples and sculptures on the Acropolis. Create a 750 word essay and an accompanying collage or digital photo presentation that demonstrate how the ideals of Classical Greek art and architecture are still prominent in contemporary society. Students are invited to share their essays and visual presentations through virtual bulletin boards or direct presentations in the classroom.

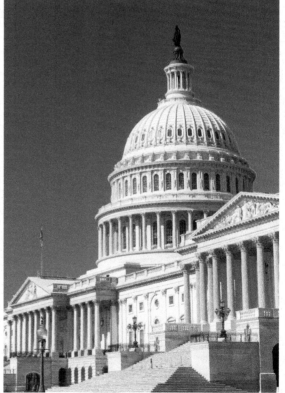

The United States Capitol, Washington, DC

Chapter 4

Pompeii: The Roman Empire

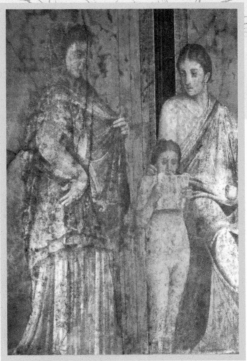

Wall Mural, Pompeii, Italy

© mountainpix/Shutterstock, Inc.

On the morning of August 24 in the year 79 ce Mount Vesuvius on the Italian peninsula erupted with little warning for the inhabitants of the city of Pompeii. According to the eye-witness report by the Roman poet Pliny the Younger, the Pompeian's found the billowing clouds that first were emitted from the active volcano a marvel rather than something to be feared.

This catastrophe trapped the residents of Pompeii unaware and the volcanic eruption covered Pompeii in a very short time with hot ash and pumice. Within twenty-four hours, the people, villas, livestock, and the artworks of Pompeii were preserved as if in a time capsule from August 24, 79 ce until today.

Coins were first in use in what is now known as Italy as early as 2300 years ago and were in use within the Roman Empire until the 4th and 5th centuries ce. Because of the steady minting of coins and the extensive use of the coinage across the vast Roman Empire, these coins are perhaps the most famous of all ancient currency.

Located overlooking the Bay of Naples, Mount Vesuvius has erupted over geological history more than fifty times. However, the eruption of 79 ce is most certainly its most well-known. The archaeological site of Pompeii was discovered in 1748 and excavation from that time forward has revealed just how intact the city of about 20,000 residents was since that fateful day in 79 ce. Structures, including the villas of the well to do, the accoutrements of daily life, and perhaps most horrifically, the remains of the inhabitants were encapsulated in rock hard body casts of solid volcanic ash and pumice.

At the time of the eruption, Pompeii had been a retreat for many of Rome's elite and its streets were lined with impressive and ornate villas. At the same time, craftsmen, merchants, and slaves were part of the flow of everyday life in the thriving town. Pompeii became interred under the mass of volcanic ash that seared the landscape and killed and entombed close to 2,000 people. Nearby towns, such as Herculaneum, were abandoned along with Pompeii until their rediscovery centuries later.

Due to this preserved environment, we are able to see the original frescoes and statues and numerous daily artifacts, such as coins and even the armor of gladiators.

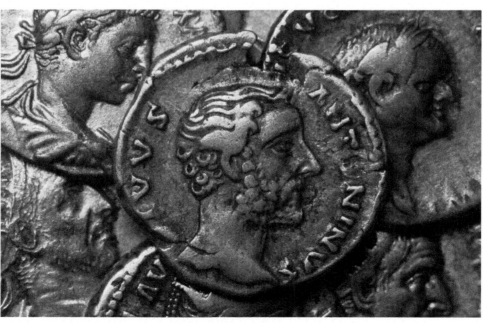

© nevio/Shutterstock, Inc.

Roman coins, AR Denarius, Antoninus Pius 138 bce Rome

Some of the most impressive surviving artworks from 79 ce Pompeii are the wall paintings that were concealed beneath the volcanic ash. These refined and tasteful paintings testify to the wealth and stature of the owners of the villas of Pompeii and its environs. Some of these wall paintings included decorative architectural elements and trompe l'oeil to suggest a broader three dimensional space within the villas and garden courtyards. The representation of everyday objects within the household, such as vases and shelves and tables are depicted within these vividly descriptive paintings.

Roman wall painting has been broken down into a few categories by art historians. In the early era of the Roman Empire about 2,100 to 2,200 years ago, the First Style emerged and was predominantly a decorative approach to wall painting. Later, during the first century before the Common Era, Roman artists were inspired by the Late Greek artists of the Hellenic era and this is considered the Late Republican period.

The city of Pompeii's wall paintings fall, predominantly, into what is referred to as The Second Style. This period saw an emphasis on trompe l'oeil fresco painting.

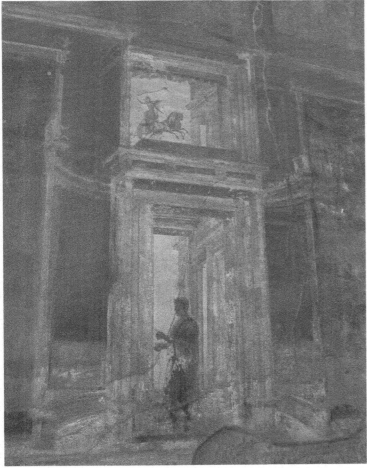

© JeniFoto/Shutterstock, Inc.

Trompe l'oeil is French for "fools the eye." Artists painting in this style from as early as Roman antiquity, such as those whom painted the murals at Pompeii, have worked to painstakingly reproduce objective reality. Their intent has been to make a two-dimensional surface, like a garden wall in Pompeii, appear to be a real three-dimensional space.

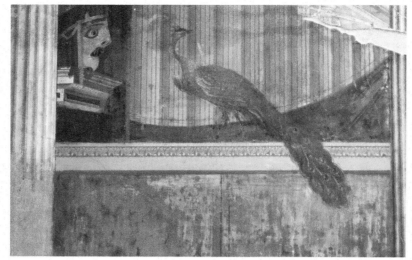

© mountainpix/Shutterstock, Inc.

CREATIVE WRITING PROJECT ..

After careful study of life in Pompeii prior to 79 ce, work collaboratively to create a one act play about life in any one of the many environments preserved by the eruption of Mount Vesuvius. Compare the life style of the wealthy residents of Pompeii and Herculaneum with those of the slaves, gladiators, merchants, and artisans that traveled the same streets as those who lived in the posh villas. Ask students to dramatize what they believe are the most interesting contrasts between life in first century Pompeii and life in the twenty-first century making sure to note the contrast in the types of art and artifacts that the Romans of this period surrounded themselves with and with the trappings that you surround yourself with today.

© mountainpix/Shutterstock, Inc.

Chapter 5

The Terracotta Warriors: The Great Wall and the Qin Dynasty

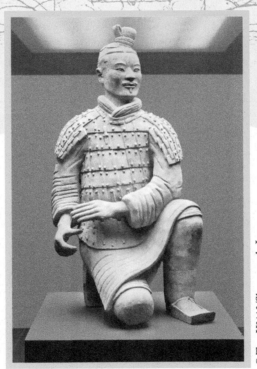

© TonyV3112/Shutterstock, Inc.

The Qin Dynasty was the shortest dynastic reign in Chinese history, lasting from 221-206 bce. After building a strong army, the Qin military elite conquered the surrounding provincial warlords and the privileged class of the then existent Zhou Dynasty. Under the Qin ruler, the Emperor Shi Huang Di, a vast stretch of China became united for the first time as one centralized empire. Shi Huang Di was

a strong dictatorial sovereign who instituted numerous highly restrictive laws, including the banning of all previous philosophies, histories, and even the burning and destruction of books and documents of all previous rulers and dynasties. On the other hand, the Emperor of the Qin created a unified currency, a standardized systems of roads and measures for things such as the width of a cart's axle, and a consistent writing system. The capital of the Qin was eventually established in the western China city of Chang'an, present day Xian, and roads were built connecting the outlying provinces to the central capital city. Much of the bureaucratic systems put in place during the Qin Dynasty became the model of government control for future dynasties in China up until 1911. A rebellion in the territories beyond Chang'an ended the brief reign of the Qin in 206 bce.

Shi Huang Di, the first Emperor of China spent much of his time in power looking for ways to assure his own immortality. He set out to protect his kingdom from aggressors beyond the purviews of his empire by beginning construction of a wall on the northern and western borders of the Qin domain. Eventually, over centuries of construction, what was begun during the Qin Dynasty would become what we know of as the Great Wall of China.

Discovered in 1974, the tomb of Shi Huang Di was soon to reveal the immense number of life size soldiers, horses, and chariots that were created to accompany the Emperor into the next world. Each individualized solider and animal was molded in clay and fired to hardness that has withstood the thousands of years of their entombment until that fateful day in 1974 when their burial place was found. It appears that as much as possible, the Qin artisans worked tirelessly to recreate their known world. However, to date, the private tomb of Shi Huang Di has never been found although, there is much speculation that his body was interred in the vicinity of where the terracotta warriors were found and placed on an island surrounded by rivers of mercury. One can only wonder what riches will be revealed if and when this burial site is ever uncovered.

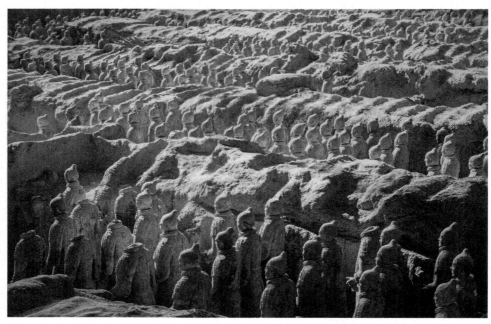

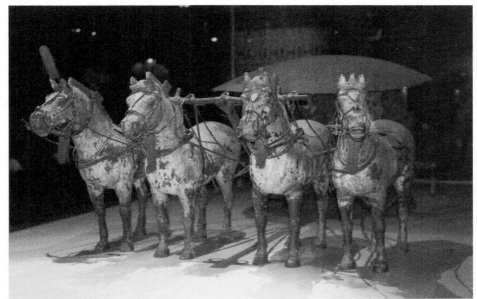
© contax66/Shutterstock, Inc.

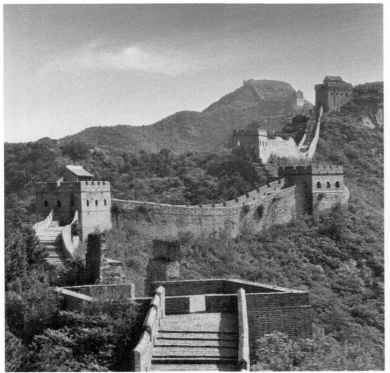
© Hung Chung Chih/Shutterstock, Inc.

The Great Wall of China is a UNESCO World Heritage Site and as such is one of the amazing wonders of human creativity and engineering know-how on the planet. Begun as a defensive system against northern and western invaders, the Wall stretches for over three thousand miles from east of Beijing to the west reaches of the Chinese empire. The serpentine Wall has strategically placed passes to allow movement across boundaries, as well as gate-towers at tactical places of importance. Signal towers were built at regular intervals so that fire signals could be set to alert the armies of the emperors of attack from external forces.

DISCOVERY PROJECT ...

Google Earth is a wonderful tool to examine the flow of the Great Wall and its crossing through the historical Qin capital city, Chang'an, present day Xian. Using this tool, virtually take an aerial view of the Great Wall and pay particular attention to the region of Xian and the historical structures and city planning that you may be able to discern through the use of Google Earth. By delving deeper into the resources on Google Earth you can find imagery of the Terracotta Warriors and of the archaeological site being excavated to uncover more of the rich artistic legacy of the Qin Dynasty.

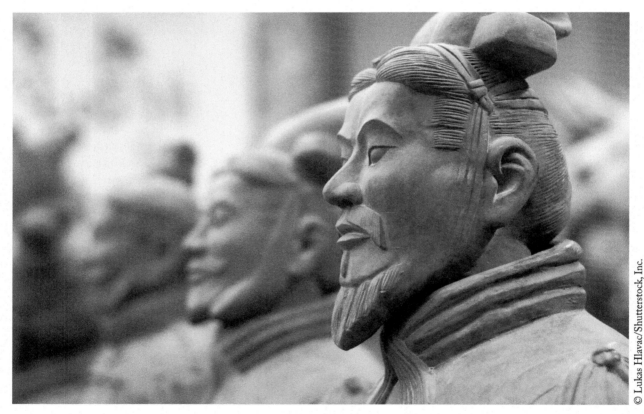

© Lukas Hlavac/Shutterstock, Inc.

Chapter 6

The Good Shepherd: The Dawn of Christian Art

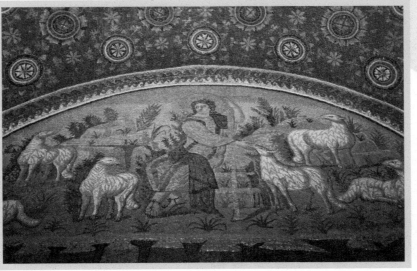

© vvoe/Shutterstock, Inc.

The Mausoleum of Galla Placidia in Ravenna, Italy houses some of the best examples of early Christian mosaics. Situated in the rear of San Vitale, this early Byzantine edifice was built in 430 ce. The Roman empress who most likely commissioned the building was never interred in the Mausoleum.

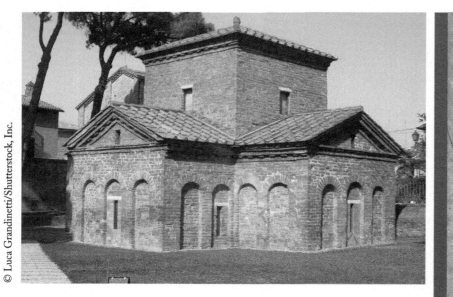

© Luca Grandinetti/Shutterstock, Inc.

Mausoleum are usually resplendent and impressive places for the burial of individuals or, in many cases, the deceased of a single family. These small buildings may have a central room with side chambers or a crypt beneath wherein the remains are interred. One of the earliest and most famous mausoleum is the one at Halicarnassus, in present day Turkey, built around 350 bce.

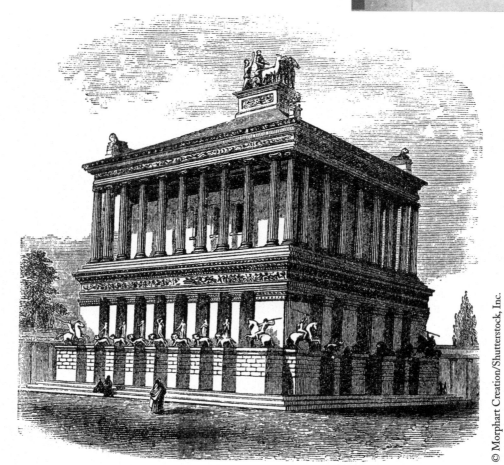

© Morphart Creation/Shutterstock, Inc.

Mausoleum at Halicarnassus or Tomb of Mausolus vintage engraving. Old engraved illustration of Mausoleum at Halicarnassus during 1890s.

Galla Placidia was the daughter of Emperor Theodosius I. She married the Roman Emperor Constantius III and she herself became a dominant figure in the empire during her reign as Empress. She died November 27, 450 ce, and, most likely, her body was not brought from Rome to Ravenna to be placed in the seminal mausoleum built for her.

Some believe that rather than built for use as a mausoleum, the elegant small chapel was built as an oratory.

Oratory usually refers to a place of prayer. Officially it is a structure other than a church which has been built specifically for prayer and the celebration of the Catholic Mass and, at times, created for a single family, which may be the case for the so called Galla Placidia Mausoleum.

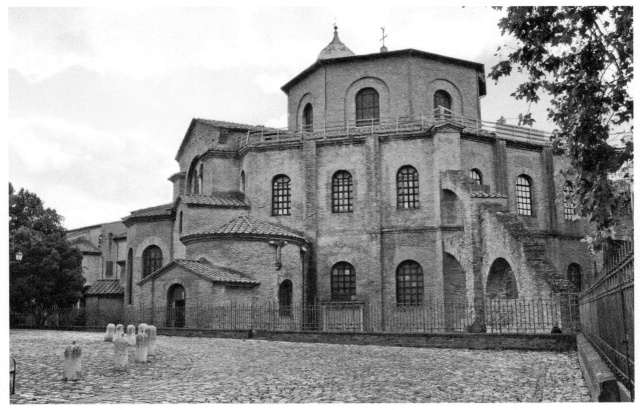

The mosaics of Galla Placidia are one of the great treasures of early Christian art known as Byzantine art. The Byzantine period in world history began in 330 ce when the Roman Emperor Constantine moved the center of his empire from Rome to present day Istanbul, formerly known as Constantinople and originally, at the time of Constantine, Byzantium.

The Byzantine period is usually noted as being from 330 to the mid-700s ce. It is during this time that Christian iconography begins to dominate the visual world of the Roman Empire and replace the Roman and earlier Greek gods and demi-gods that stood out in the artistic imagination of earlier artists, architects, and artisans.

During this time period, the Byzantine created magnificent illuminated manuscripts as well as relief and three dimensional and free standing sculpture and, quite distinctly, detailed mosaics portraying both biblical and secular personages.

© guroldinneden/Shutterstock, Inc.

Mosaics are murals created with small pieces of colored glass and sometimes with cut stone pieces. These pieces of glass or stone are known as tesserae. Mosaics may be set into the floor or vertically on walls or even on domed ceilings.

The Good Shepherd mosaic is in the lunette above the west entrance of the oratory of Galla Placidia. The Christian symbolism associated with the shepherd as a merciful and compassionate guide to his flock may have originated in earlier Roman and Greek iconography used for similar metaphorical purposes. But, it is during the Byzantine period and the explosion of symbolic Christian imagery that the shepherd image comes to reference Christ and appears in sculptures, mosaics, and illuminated manuscripts. In this particular exemplary mosaic, Jesus the shepherd tends to his flock and, instead of holding a crooked staff common for shepherds of the day, his staff is that of a golden cross. The scene could be one that the residents of Ravenna, Italy may have found familiar: a shepherd and his flock upon the fertile fields above the rocky coastal cliffs sitting placidly under the bright blue Mediterranean sky.

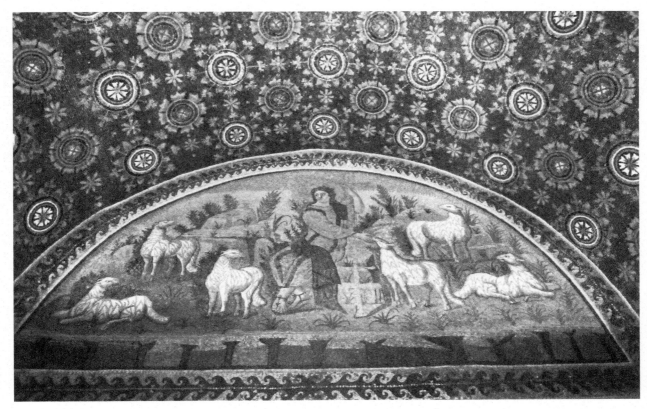

STUDIO PROJECT

Using colored papers as a substitute for small pieces of colored glass and stone, create, on large paper or pieces of papers taped together, a mosaic using iconography from the early Byzantine time period. Research mosaics such as the Good Shepherd in Ravenna, Italy and use those examples as a template to create your own mosaic. Note the ways Byzantine artists depicted the human figure and pay special attention to how the feet and facial expressions were portrayed.

Chapter 7

The Great Buddha of Kamakura: Buddhist Art

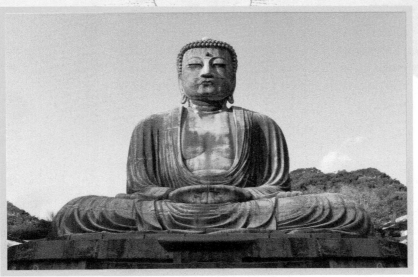

© Napatsan Puakpong/Shutterstock, Inc.

Buddhists believe that the historical Buddha was born about 2500 years ago as a member of the Shakya clan and is therefore referred to as Shakyamuni, or Sage of the Shakya Clan in northern India. His story begins as a prince secluded from the realities that surrounded his family's enclave. Much of the suffering of the world he grew up in was kept from him and it was not until he had reached maturity that

he ventured out into the world of poverty and sickness. On one of his excursions into the community beyond his family's reserve he encountered a Hindu holy man whose abstemiousness became a model for Siddhartha, the name bestowed upon him at a young age. He left the comfort of his family's home and lived austerely and in self-denial of comforts he had become used to. After a number of years of severe abstinence he came to the realization that such strict physical abstinence was not the path to enlightenment. He chose to meditate under a tree now known as the Bodh Gaya or enlightenment place. After much meditation and contemplation he achieved an enlightened state and became a Buddha or enlightened one.

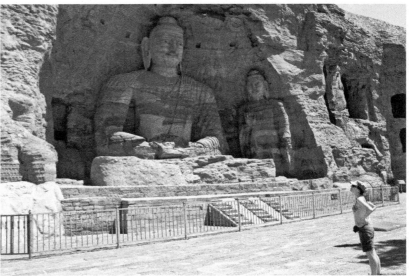

© Greir/Shutterstock, Inc.

Shakyamuni, the Buddha, after his enlightenment began to travel through India and teach his philosophy of a middle way toward truth and spiritual awakening. After the historic Buddha's death, it is said that his cremated remains were distributed among his followers and that these relics were interred in what are now known as Stupas or Pagodas.

The concept of a pagoda is the same as a stupa, which originated in India, in that they are places to store and maintain holy relics and texts. In China, the Indian stupa, which is rounded, was transformed into a multi-story structure with distinct architectural characteristics. This architectural form, the Pagoda, was transmitted to other parts of Asia. Pagodas have three main parts: the top, much like Indian stupas have spires projecting upward; the main part or body of the pagoda often has a statue and other artwork of the Buddha within its walls and; the base, a place to bury the relics of the particular temple associated with the pagoda.

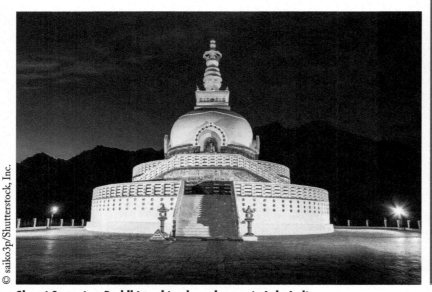

© saiko3p/Shutterstock, Inc.

Shanti Stupa is a Buddhist white-domed stupa in Leh, India

Buddhist art spread from northern India to all parts of Asia and now, to every corner of the world. The life of the historic Buddha forms a large portion of Buddhist iconography as created in all forms and scales of sculptures and paintings. From the birth of the historic Buddha to his enlightenment and his death, cultures from Tibet to Japan have adorned the outside and inside of temples with this powerful and poignant life story. Along with the historic Buddha or Shakyamuni, Buddhist art includes depictions of Bodhisattva or celestial beings and other Buddha besides Shakyamuni, such as the Amitabh Buddha, the Buddha of the Western Paradise or the Maitreya Buddha, the Buddha of the future.

Buddhism in all its variety and Buddhists from diverse sects and practices, have in common the essential belief in the Four Noble Truths: 1) all life is suffering; 2) this suffering is caused by attachments and desires; 3) that to stop suffering is to stop

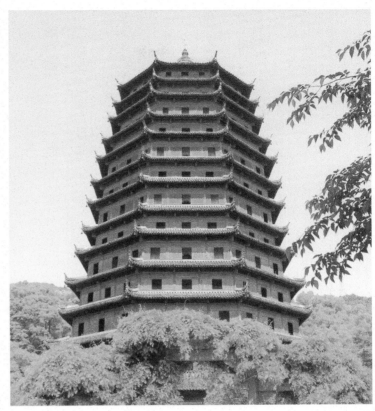

Pagoda of Six Harmonies, Hangzhou, China

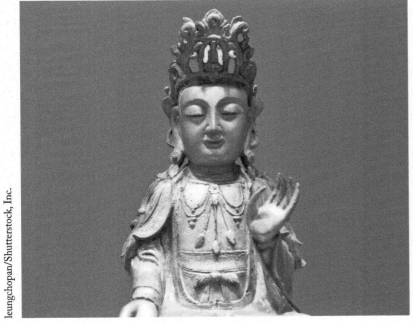

Kannon, the Bodhisattva of Compassion

Buddha or Bodhisattva? Bodhisattvas are individuals who, after achieving enlightenment, opt to remain in the world to help others. These saintly beings are depicted wearing elaborate clothing, jewelry, and ornate headdresses. In Buddhist iconography, the historic Buddha, who has already passed on to nirvana, is depicted wearing simple monk's robes and no ornamentation at all.

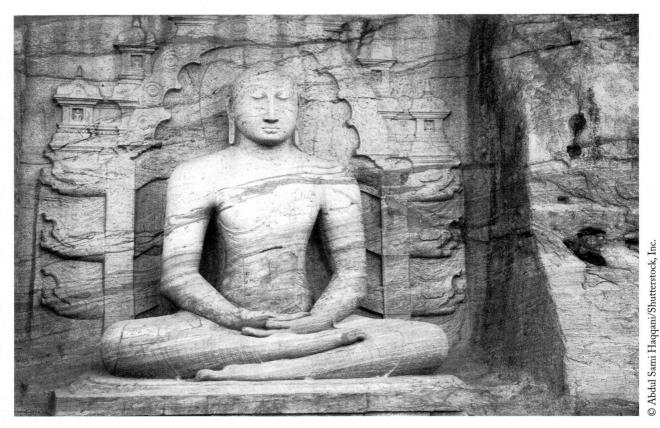

The statues of the Buddha at Polonnaruwa, Sri Lanaka were cut into a granite wall in 12th century. Depicted here is the seated Buddha in meditation. Polonnaruwa is a UNESCO World Heritage site.

attachments and desires, and; 4) that to follow the Buddhist Eightfold Path is the way to end attachment and desire. The Eightfold Path is a set of guidelines to help in one's practice toward enlightenment and the end of suffering.

The Great Buddha of Kamakura (Daibutsu in Japanese) dates back to 1252 ce and is a massive bronze statue of Amida Buddha in the city of Kamakura, Japan. Located at Kotokuin-ji, a Buddhist temple of the Pure Land sect, the Great Buddha is one of the most known works of Buddhist art in the world. The seated Buddha is in a meditation posture and his legs are folded in the lotus position.

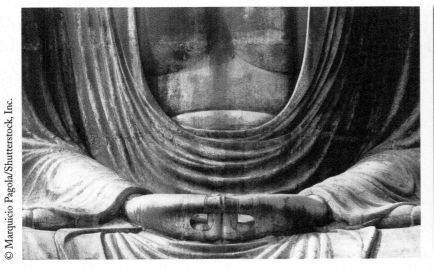

In Buddhist art, figures are portrayed with their hands making specific gestures or mudras. Mudras are indications, at times, of the particular Buddhist deity being represented and also are indications of the actions of the deity or focal points of interest and use for the disciple.

The meditation mudra

LOOKING PROJECT .

Using the Great Buddha of Kamakura as a model, take a close and careful look at the elements of the sculpture. Take a few moments to position yourself in the same posture as the Great Buddha paying particular attention to the Buddha's facial expression and hand gesture. Contemplate what the intention of this sculpture is supposed to communicate. What do you see in this sculpture that might suggest the Buddhist belief system? How does the clothing worn by the figure suggest who this sculpture represents? Additionally, how does this figure differ from representations of Bodhisattva? What other mudras or hand gestures might have been used in the representation of this Buddha?

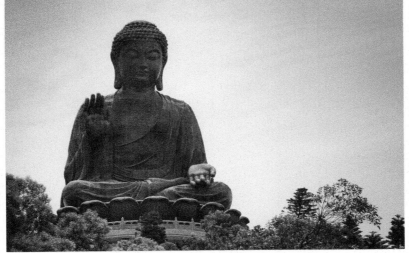

Tian Tan Buddha on Lantau Island in Hong Kong. It is 34 meters tall and is a major center of Buddhism in Hong Kong.

Chapter 8

Persian Miniatures: The Art of Islam

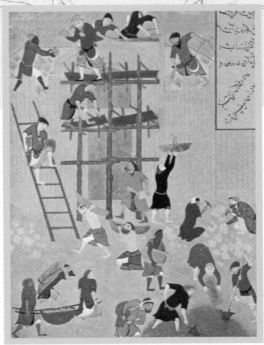

Building a palace, miniature by Kamal ud-Din Behzad, British Library, London.

Construction of the Castle of Khawarnaq, Herat, Khorasan, 1494 (gouache on paper), Bihzad (Kamal al-Din Bihzad) (1450-1536) / British Museum, London, UK / Bridgeman Images

Persia was in what is now present day Iran, and it was one of the greatest empires in world history. A rich tradition of various art forms was created during the years of the ancient Persian Empire until its demise at the hands of Alexander the Great. Weaving, metal work, pottery

and ceramics, calligraphy, architecture, garden design, and miniature paintings were just some of the art forms that reached highly sophisticated levels of creativity. Persian culture continued to thrive after the time of Alexander the Great and in later centuries the Persians adopted Islam as one of their religious traditions which, in turn, had enormous influence on the artistic output of the Persian peoples.

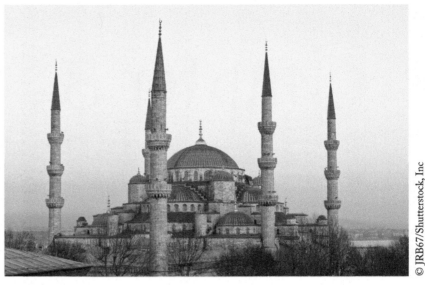

The Blue Mosque

In 641 ce, Persia became part of the Islamic world and they adopted Islamic aesthetic traditions and dictates which came to dominate the creative imaginative works of the Persians. Architecture and decorative arts thrived during this time period as did the art of carpet weaving and highly colorful ceramic ware, as well as substantially ornamental metalwork. The Blue Mosque at Tabriz in Iran is an extraordinary example of the exceedingly sophisticated architectural decorations and craftsmanship that is a hallmark of Islamic Persian architecture.

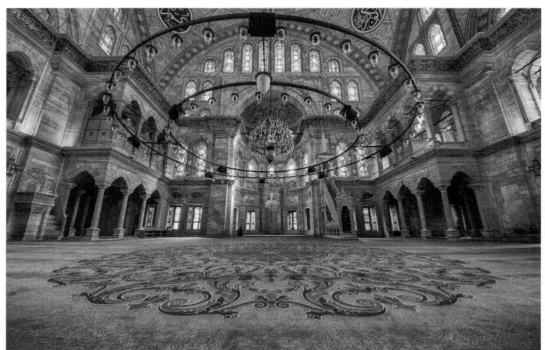

Interior of the Blue Mosque

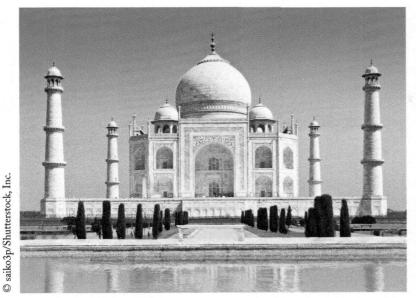

The Taj Mahal, Agra, India

The Mogul Empire controlled most of present day India, Pakistan, and Iran and came to power around 1500 ce and lasted into the 17th century. The Moguls spread Islam across its empire and, very distinctly, Persian art forms and styles.

Since Islam forbids the representation of human figures in painting and sculpture, Persian artists became highly adept at producing some of the world's most beautiful illuminated manuscripts and miniature paintings. During the Mogul rule of the Persian empire, calligraphy and miniature paintings reached a level of elegance that has rarely been equaled.

One of the most well respected of these painters of miniatures was the man known as Behzad who worked during the late fifteenth century ce. Behzad was born in the city of Herat in what is now modern day Iran. His talents were recognized at a young age. His first position of importance was in the royal library of Sultan Hussain Bayeqra. Later, he became the director of the royal library in Tabriz. He was not only acknowledged for his fine painting but as a teacher of his craft. Few of his paintings are extant. His rich use of color, dynamic composition, and realistic portraiture are hall marks of his miniatures.

The painters of the late 15th century in Tabriz manifested works that indicate very close observation of nature and the built environment. Sometimes quite dramatic in their subject matter, they also produced works of calm and serenity illustrating every day scenes such as the building of a palace or students at their lessons.

STUDIO PROJECT ...

The work presented below from the British Library collection depicts a school scene with both boy and girl students, as well as their teacher. Layla and Majnun at school with other pupils is a miniature painting from a 15th century manuscript of Nizami's Khamsa ('Five Poems'). The image is taken from this text. Created in Herat, 1494-1495 ce. Behzad, along with his teacher Mirak Naqqash and his pupil Qasim Ali, illustrated Nizami's *Khamse* manuscript, which is an exemplar of Persian miniature painting. Using the style of Behzad's painting in this sample, create your own miniature painting that illustrates a scene from a story of your choice.

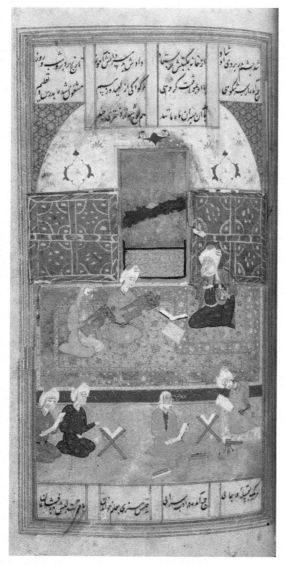

Or 1216 f.135r Laila and Majnum at school, from the 'Khamsa' of Nizami, 1524, (gouache on paper), Persian School, (16th century) / British Library, London, UK / © British Library Board. All Rights Reserved / Bridgeman Images

Laila and Majnum at school, from the 'Khamsa' of Nizami, 1524, (gouache on paper), Persian School, (16th century) / British Library, London, UK.

Chapter 9

The Book of Kells:
The Middle Ages

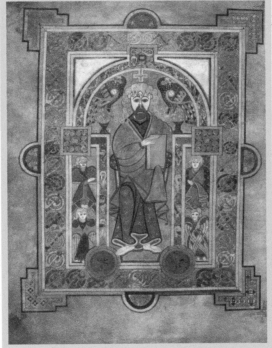

Christ Enthroned

MS 58 fol.32v Christ with four angels, introductory page to the Gospel of St. Matthew, from the Book of Kells, c.800 (vellum), Irish School, (9th century) / © The Board of Trinity College, Dublin, Ireland / Bridgeman Images

I n the very early years of the ninth century the island of Iona, located off the coast of Scotland, was invaded by Vikings. The monks of the Columban order who resided in a monastery on Iona fled to the village of Kells in the county of Meath in present day Ireland and built a new monastery. It was at these locations, Iona and Kells, that the monks created one of the most magnificently illustrated books in the history of humanity.

This text is known as the Book of Kells and is housed in the library of Trinity College in Dublin, Ireland. It is written and illuminated on vellum and details, in Latin, four Gospels of the New Testament.

Perhaps the finest example of Celtic art, the Book of Kells is a masterpiece of detailed and intricate painting and calligraphy. Portraits of figures from the Gospels and myriad beasts are intertwined within the framework of complex patterns and knots and detailed in vivid colors and strong linear definition. The pigments used came from natural ores and minerals were bound together with egg white and applied to the calf skin leafs of the folio.

Trinity College Library is the largest library in Ireland and home to The Book of Kells.

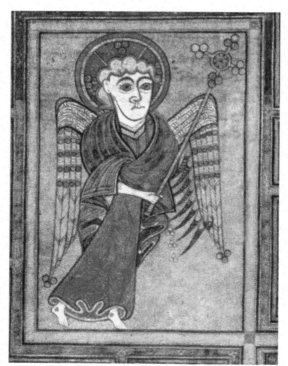

MS 58 fol.27v Introductory page to the Gospel of St. Matthew depicting winged symbols of the Four Evangelists framed in panels, from the Book of Kells, c.800 (vellum), Irish School, (9th century) / © The Board of Trinity College, Dublin, Ireland / Bridgeman Images

The Gospel of Mathew, the Symbol of Mathew

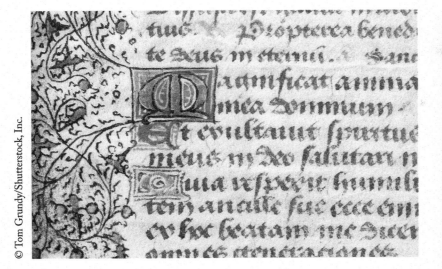

© Tom Grundy/Shutterstock, Inc.

Illuminated manuscripts are handwritten texts or manuscripts (which means, in Latin, handwritten) and, in many cases, refers to books produced before the invention of the printing press. As with the Book of Kells, many illuminated manuscripts are highly detailed and took much time and labor to produce. The surface for these illustrated books was most often vellum which are animal skins that have been stretched and treated to serve much like parchment paper. Illuminated is another Latin word meaning "enlightened" and refers to the decorative use of color and, sometimes, gold leaf that embellish the written text.

The Monks at Kell lived a monastic life not much different than other such monastic communities in the early Middle Ages. They lived a communal life devoted to prayer and labor. In the case of the Columban Monks, their labor was in illuminating the four Gospels of Mark, Matthew, Luke, and John.

The Book of Kells is comprised of folios or folded sheets of vellum. The word folio derives from the Latin for leaf and there are three hundred and forty surviving folios in the Book of Kells. Almost all of these leafs or pages of the manuscript contain highly ornamented illuminations. The individuals who hand wrote and illuminated the Book were Columban monks, or followers of St. Columba who was born about two hundred and forty years before the production of the Book of Kells.

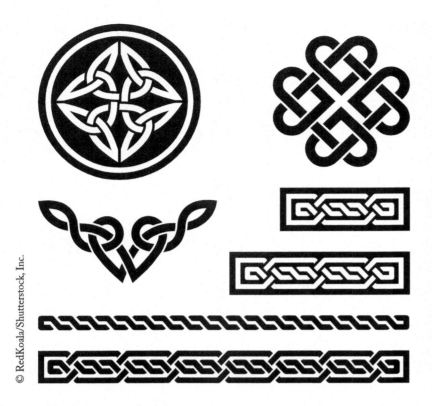

© RedKoala/Shutterstock, Inc.

Celtic knots, braids, and patterns

LOOKING PROJECT ...

The Book of Kells has many of the same elements of modern books. Look carefully at the Christ Enthroned leaf from the Book of Kells and detail what elements of this ornately decorated page are similar to what you might find in a contemporary illustrated book such as a graphic novel or manga. Examine the use of color, design elements and principles, and the layout within the borders of the page and reflect on how these factors are similar or not to contemporary illustrated books. Examine closely all the elements of the image: the figures and animals; Christian iconography; and Celtic decorative motifs. Do a bit of research and find out how and from where the monks produced such vivid colors.

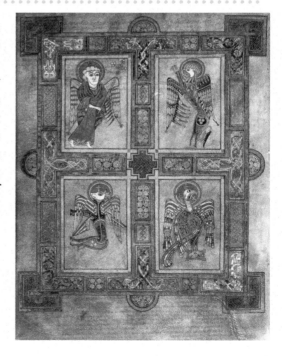

MS 58 fol.27v Introductory page to the Gospel of St. Matthew depicting winged symbols of the Four Evangelists framed in panels, from the Book of Kells, c.800 (vellum), Irish School, (9th century) / © The Board of Trinity College, Dublin, Ireland / Bridgeman Images

Chapter 10

Chartres Cathedral: The Gothic World

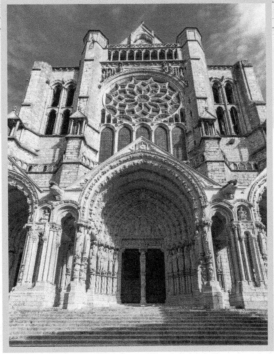

Chartres Cathedral

© Alex Justas/Shutterstock, Inc.

Chartres Cathedral is a UNESCO designated World Heritage Site that was begun as early as 1145 ce and is a prime example of Gothic architecture in France and beyond. The cathedral is extensively adorned with splendid sculpture and stunning stained glass windows. Located in the city of Chartres, about fifty miles from Paris, the cathedral is a massive structure supported by flying buttresses and has two unique and dissimilar spires, one reaching about 380 feet and the other approximately

350 feet into the air. The cathedral also has three substantial facades which are adorned with significant sculptural elements.

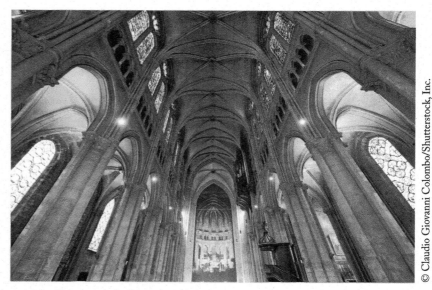

Interior Chartres Cathedral

© Claudio Giovanni Colombo/Shutterstock, Inc.

Chartres is more formally known as Notre-Dame d'Chartres and is significant for its well preserved structure and its exemplary stained glass windows. During the Middle Ages, the cathedral was a major destination for pilgrims. Built upon the ruins of a Romanesque church, the current limestone building soars to over 110 feet across its over 425 foot length. The immense weight of the stone is held in place by buttresses which also allow for great piercing of the skin of the cathedral allowing light to penetrate the main body or nave of the cathedral.

Figurative sculptures are a prominent feature of the cathedral and they largely are representative of the teachings of the Catholic church. The numerous stained glass windows throughout the cathedral also serve as didactic tools of the church providing pilgrims with a visual narrative of the people and stories of both the Old and New Testaments. Pilgrims during the early centuries of the cathedral's life were mostly illiterate and therefore these vast and strikingly beautiful works of art became the means by which to share in the church's teachings.

© Tupungato/Shutterstock, Inc.

Flying buttresses of Chartres Cathedral

The Gothic period in art is usually demarcated as between the 12th and 16th centuries and is characterized best by the architecture of the time, such as Chartres Cathedral. The term Gothic was used during the Renaissance as a reminder or indication that the Goths were the people who defeated the Roman empire and thus bringing in a new age of Christianity in Europe.

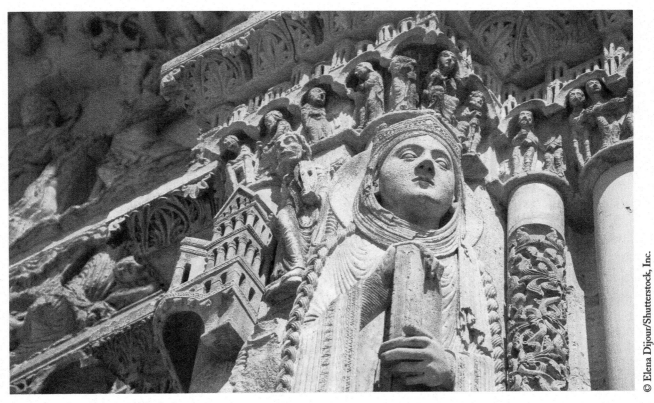

Royal Portal, Chartres Cathedral

The Royal Portal, one of the three main portals of the cathedral was built from 1138-1143 and is amazingly complex and detailed and includes some of the finest examples of Gothic sculpture anywhere in Europe.

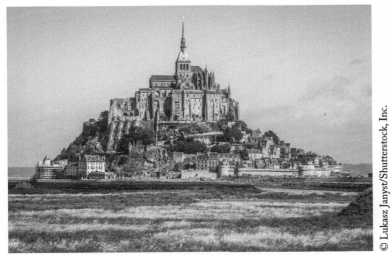

Mont Saint Michel, Normandy, another cathedral on the Pilgrim's route in France.

During the centuries of the Middle Ages and the Gothic era, Christian believers traveled along specific routes, from one cathedral city to another, in order to fulfill their spiritual goals and to experience the teachings of the Catholic church through the specific orientations of each cathedral. Chartres Cathedral was and continues to be associated with Mary, the mother of Christ.

The primary mission and emphasis of Gothic architecture is to produce soaring structures that reach ever higher toward the heavens, connecting earthly endeavors with heavenly pursuits. The engineering obstacles to erecting stone cathedrals were enormous and the invention of the flying buttress to hold steady and solid the ever ascending walls of the cathedral was a major step forward in the history of architecture. The high ceilings and pierced walls of the cathedral allowed for a light full and expansive experience that must have elevated the spirits and awed the emotions of the pilgrims and parishioners who streamed into these towering edifices.

RESEARCH PROJECT ...

Using internet resources, explore the construction techniques of the Gothic era architects and floor plans and cross sections of the cathedrals' engineering attributes. Write about and illustrate with internet images, the architectural elements of a Gothic cathedral such as the Chartres Cathedral and how those elements illustrate the intentions of the Catholic church at that time.

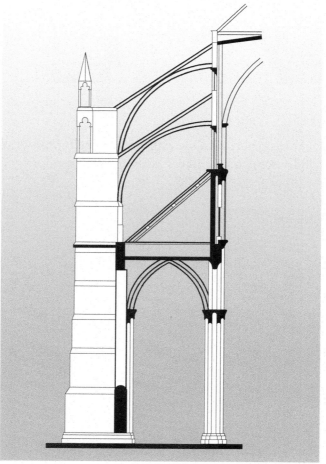

© gattopazzo/Shutterstock, Inc.

Chapter 11

The Lamentation of Christ by Giotto: The Start of the Renaissance

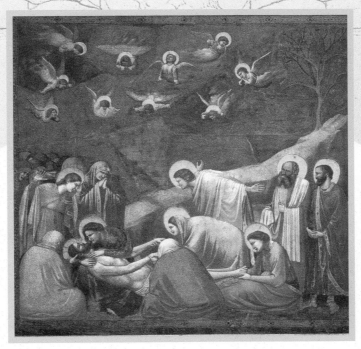

The Lamentation of Christ, c.1305 (fresco), Giotto di Bondone (c.1266–1337) / Scrovegni (Arena) Chapel, Padua, Italy / Bridgeman Images

Giotto's Lamentation of Christ

The Lamentation of Christ is a fresco painted by the artist Giotto in the years 1305-1306 in Padua, Italy in the Arena Chapel. Approximately seven and a half feet by eight feet, the center forefront of the painting portrays the dead Christ being mourned and tended to by three women and two other figures who are turned away from the observer. One of the figures, with auburn or red hair caresses the feet of the Christ figure. This may be the iconographic representation of Mary Magdalene.

Behind and above the dead Christ and his attendees are the depiction of five figures. Most prominent of these figures is a man with his arms thrust outwards bent over the Christ figure. His hair style and his shaved face most likely are the symbols of St. John. As with the female figures below him, St. John's head is haloed as are the heads of the other male disciples on either side of St. John. To the left, a group of people, perhaps other mourners, congregate in the background. Above and beyond the action are eleven angels.

Giotto's Lamentation of Christ has a strong linear composition much like earlier Byzantine paintings but this fresco represents a departure from the stylistic representations of the Middle Ages and brings forth a new sense of realism that will be further refined over the next few centuries. Giotto employs a traditional technique of representing perspective by placing those figures that are to be perceived as closer to the viewer at the bottom of the painting and those figures and pictorial elements such as the landscape that are to be thought of as further away from the viewer in successive layers moving up the plane of the painting surface. This use of pictorial space provides a sense of depth and action that takes place in a more realistic space.

Giotto's painting is a seminal work of art in that it bridges the pictorial representational style of the Middle Ages with the highly realistic perspective and mimetic style of the high Renaissance. Giotto's fresco is part of a number of paintings in the Arena Chapel in Padua that depict the life, death, and resurrection of Christ.

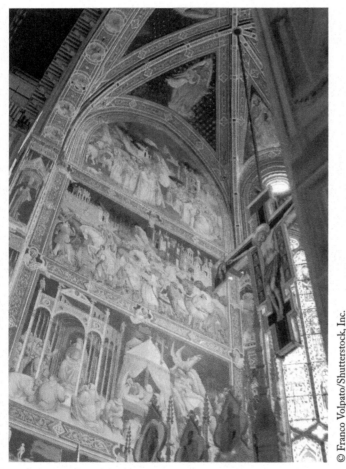

© Franco Volpato/Shutterstock, Inc.

The frescoes in the Church of Santa Croce in Florence, Italy

A fresco is an ancient painting technique that was fully developed during the Renaissance and where in paint is applied to a moist lime plaster surface. Fresco is an Italian word meaning fresh.

Giotto was a painter and architect who was born in Florence, Italy in 1267 and who died in 1337. His full name was Giotto di Bondone and he is widely considered the first of the great Italian Renaissance artistic giants. According to art historians, Giotto became a student of the Florentine artist Cimabue at the age of twelve. His fresco work probably began with his series of paintings of the life of St. Francis in a church in Assisi, Italy. In 1305 he began his extensive series of fresco paintings for the Arena Chapel in Padua. The Lamentation of Christ is one of thirty-eight such frescos in the Chapel. His work is characterized by a straight forward and realistic depiction of the figures portrayed and in stark and vividly bright landscapes.

Iconography is the visual representation of ideas, values, personages, and concepts through images and specific symbols. In Giotto's fresco The Lamentation of Christ he employs numerous graphic images that represent specific Christian individuals (such as the youthful and clean shaven St. John) and specific aspects of Christian doctrine and faith (such as the death of Christ as part of the account of the life, death, and resurrection of Christ).

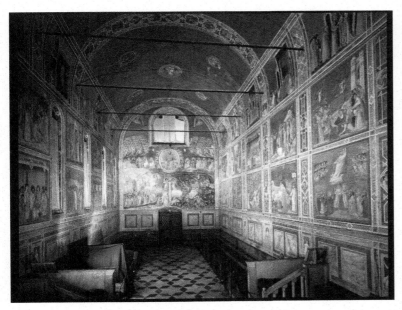

View of the chapel looking towards The Last Judgement, c.1305 (fresco), Giotto di Bondone (c.1266-1337) / Scrovegni (Arena) Chapel, Padua, Italy / Bridgeman Images

The Arena Chapel, Padua, Italy – note the Lamentation of Christ on the lower left panel.

STUDIO PROJECT ..

Do some further research on fresco painting techniques and examine the processes that Giotto and other artists used to produce their long lived paintings. Focus on a small detail of the fresco Lamentation of Christ and sketch that detail on a letter size piece of paper. If you are adventurous, you may mix a batch of wet plaster onto a one foot square piece of thin wood and reproduce your sketch with tempura paint onto the wet plaster. If not so inclined, you can simply use pastels or tempura paint to complete your detail of Giotto's masterpiece.

Chapter 12

Mona Lisa by Leonardo da Vinci: The Genius of the Renaissance

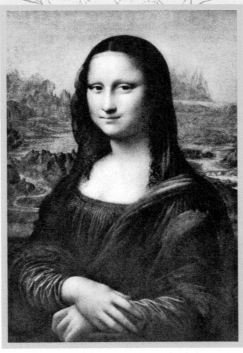

© Oleg Golovnev/Shutterstock, Inc.

Perhaps the most famous painting in all of history, Mona Lisa was painted by Leonardo da Vinci around 1503-1506. The model is of Lisa, the wife of Francesco del Giocondo and the painting resides at the Louvre in Paris, France. The portrait is a masterpiece of sfumato or of softly and seamlessly painted strokes that blend perfectly without any outlining or hard lines. The delicate touch of the artist deftly captured the reality and mystery of the Lady Gioconda. Her gaze is direct and to-

ward the viewer, her smile abstruse and maybe the most famous smirk in all of art history. The folds of Mona Lisa's dress, the curve of her shoulders, the fine tendrils of her coiffure all mesh with the ox bowing river and receding landscape that blends effortlessly into an ethereal sky.

Leonardo da Vinci was born in 1452 and died in 1519 and is recognized universally as one of history's most famous geniuses. Artists, designer, architect, engineer, inventor, he is the epitome of the Renaissance man. Whether divinely inspired, preternaturally talented, or the product of extensive training and hard work, his output, while somewhat scant in comparison to other artists, is most recognizable as the work of a great master. His copious drawings and studies for his murals and paintings are a special record of a highly curious and active mind.

Besides the Mona Lisa, probably his next most famous painting is The Last Supper begun about a decade before his portrait of the Lady Gioconda in 1492-1498 which is in the refectory of Santa Maria delle Grazie in Milan, Italy. Leonardo's attempts at

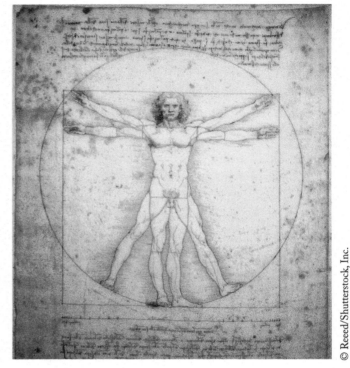

Vitruvian Man

a new approach to fresco painting, one in which he hoped his work would more vibrantly demonstrate his powers as a painter, unfortunately failed as a lasting preservation of his use of color. The work is a dramatic narrative that is set like a play in the midst of the real action of the Last Supper itself. The observation of the human dynamic and the underlying psychological nature of each player at the Supper is masterfully unfolded by Leonardo da Vinci.

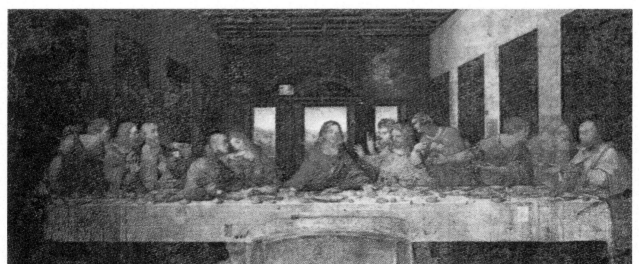

The Last Supper by Leonardo da Vinci

WRITING PROJECT..

Write a short one act play whose setting is a dinner at your home and the guest, besides yourself, are Leonardo da Vinci, Michelangelo, and any other person you would like to invite, this could be a friend, a person from history, a famous person alive today, or a character from fiction. Remember to set the scene for your audience and write about the place where the dinner is held, what you all will be eating, and, of course, the dialogue that takes place between the four of you and any action that the characters might enact.

The Renaissance literally means "new birth" and is used in art history as a designation for the time period of the fifteenth and sixteenth centuries in Europe. This rebirth was an artistic, intellectual, and cultural revolution whose origins were in Italy but whose impact was wide spread. The Renaissance was both a time of inquiry into the philosophy and aesthetics of Classical Greek and Roman times as well as a probing of the objective reality of the day.

Chapter 13

The Sistine Chapel by Michelangelo: The Height of the Renaissance

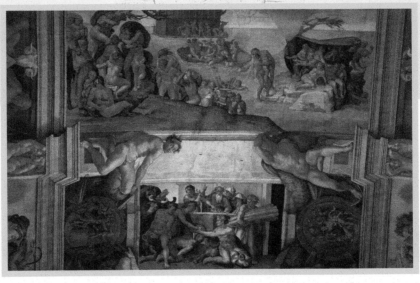

The Drunkenness of Noah shows the fall of mankind and its rebirth with Noah, chosen by God as the only man to be saved for repopulating the earth.

Michelangelo Buonarroti was born in Florence, Italy in 1475 and died in 1564. His fame as a sculptor and painter are equaled only by Leonardo da Vinci in the pantheon of great Renaissance artists. He was, like da Vinci, an inspired and inspiring genius whose legacy is unmatched in the world of art. He apprenticed under the artist Domenico Ghirlandaio when he was thirteen years old where he began his training

as a painter of frescos. He later was schooled in sculpture under the tutelage of Bertoldo di Giovanni and he quickly became a master of marble sculpting and began receiving commissions in Florence, Bologna, and Rome. In 1498 be began one of his supreme masterpieces for St. Peter's Basilica in Rome, his magnificent sculpture Pieta. In 1501 he returned to Florence and in that year began what would be another of his iconic marble sculptures and one of the most well recognized sculptures in the world, his work of genius, David.

Michelangelo's sculptures and mural paintings became models of creative expertise and virtuosity for younger artists in Italy, including Raphael, who along with Michelangelo and Leonardo da Vinci may be considered the paramount of Renaissance artists.

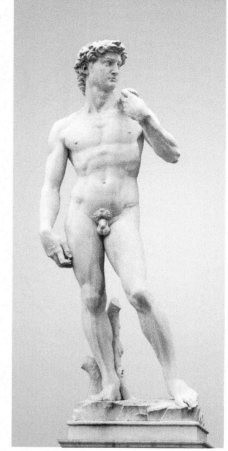

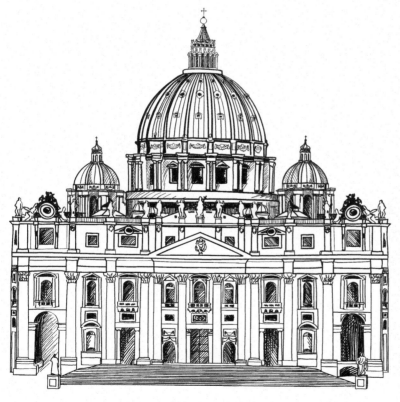

St. Peter's Basilica is located within Vatican City in Rome, Italy. Designed by Donato Bramante and later Michelangelo, the church is one of the greatest examples of Italian Renaissance architecture and one of the most visited attractions in the world. The Basilica is the burial place of the Catholic Saint Peter and by tradition, the first Pope and Bishop of Rome.

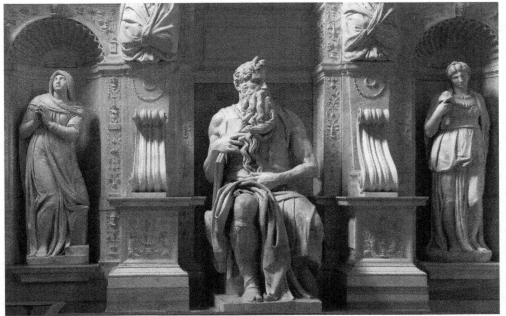

© Tupungato/ Shutterstock, Inc.

Rome, Italy. One of the most famous sculptures in the world - Moses by Michelangelo, located in San Pietro in Vincoli basilica.

In 1505, Pope Julius II commissioned Michelangelo to fabricate a tomb for him. Julius II died in 1513 but the tomb was not completed until 1545 and by that time, the only piece of the monumental tomb carved by Michelangelo was the statue of Moses.

However, Pope Julius II, before his death, employed Michelangelo to produce another work of art for the Sistine Chapel in Vatican City. Michelangelo began work on the ceiling in the autumn of 1508 and completed the epic task in late October of 1512. After four years of laboring on the fresco, the sculptor Michelangelo produced one of history's greatest paintings.

The ceiling fresco depicts scenes from the Old and New Testaments, from Genesis to the life of Christ. The depth of emotion, the clarity of depiction, the vibrancy of color, and the technical virtuosity to bring together such stirring and grand themes is unsurpassed by any other work of painting in recorded time.

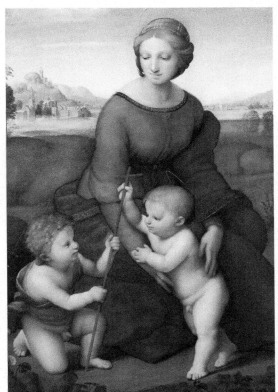

© jorisvo/ Shutterstock, Inc.

The Madonna of the Meadow, painting created by the famous renaissance artist Raphael (1483-1520) in 1505.

The last decades of his life were devoted more to architectural projects than to individual works of sculpture or fresco painting. His most significant architectural work may be found in Rome where he worked on the completion of St. Peters which, unfortunately, he did not get to see his vision for the church realized during his lifetime.

RESEARCH PROJECT ...

Using the following web site: http://www.wga.hu/tours/sistina/index3.html and other internet resources, take a self-guided virtual tour of Michelangelo's famous frescos for the Sistine Chapel. Familiarize yourself with the physical properties of the Chapel and the distinctive panels painted by Michelangelo, as well, study the life of both Pope Julius II who commissioned the paintings and the biography of Michelangelo Buonarroti. Inquire, via the Internet, into the history of Vatican City and the role of the Catholic Church during the Renaissance period. Finally, write a one page account of what you find most inspiring about the Sistine Chapel, its frescos and the stories behind the creation of these glorious paintings.

Chapter 14

Indian Sculpture: The Hindu World

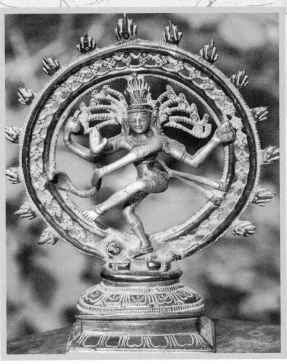

Shiva

Much of the historical sculpture of India depicts deities from the great religious traditions that have their origins in the world's second most populace nation. In Chapter 7 we examined Buddhist sculpture and the transmission of Buddhist thought from northern India across the Asian continent to Japan and beyond. In this chapter we will look at the practice of Hindu inspired and based sculpture as found

in India. Traditionally, the sacred sculpture of Hinduism has been wrought as a focal point for contemplating the divine. At times impenetrable, these sculptures are often anthropomorphic or quite human in appearance but, at all times the art serves as a pointer to the sacred and the deific.

© shymko-svitiana/Shutterstock, Inc.

The representation of Shiva at the outset of this chapter is an apt icon for the complexity found in Hindu art history. Shiva dancing in a ring of fire is an artistic invention that goes back to the Chola Dynasty in India during the ninth to thirteenth centuries. Shiva is both the Creator and the Destroyer and in his dance he holds the damaru or drum from which he sends out the vibrations that are the music of creation. With another hand he makes the mudra or hand gesture signifying protection and in yet another hand he holds the fire of destruction. With his feet he steps upon the personification of illusion and with his dancing legs he symbolizes freedom from attachment. As a unified image, Shiva is thusly representing the Hindu pursuit of salvation from the illusions of the world and a beacon to eternal salvation.

The Hindu religion has at its foundation a number of basic beliefs. Followers of the Hindu faith believe that one should strive to live righteously or to pursue the dharma. They also believe that one should follow a righteous profession that helps to enrich one's own life and that of others or artha, as well, they believe that love and loving compassion or kama are basic to the human condition and, that people should strive for a spiritual life or moksha.

These characteristics of Hinduism are manifested in the sculpture found in Hindu Temples and elsewhere. These works of art may, therefore, be at once sensual as in the pursuit of artha and, as well, display spiritual guidance. The various deity in the Hindu pantheon have been portrayed, at times, with multiple arms and multiple heads. Depending on the specific deity, this most often represents the action of cosmic battle embodied by that divinity. Demons and deities in the Hindu lore battle, transform, have avatars of themselves,

© 9photos/ Shutterstock, Inc.

Indian brahmin (traditional Hindu society) priest praying in Hindu temple Tiruchirappalli Rock Fort, Tamil Nadu, India

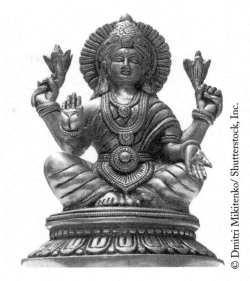

© Dmitri Mikitenko/ Shutterstock, Inc.

Vishnu

and take their place in the epic literature and scripture of the religion. This is all fodder for the fertile imaginations of Indian sculptors over the centuries.

Much of Hindu sculpture is intimately part of the architecture of Hindu temples. Hence, a Temple devoted to Shiva or Vishnu may very well have numerous sculptures of the incarnations of the specific deity throughout and intertwined with the Temple structure.

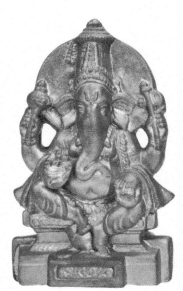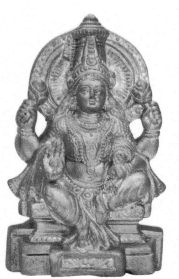

© imagedb.com/ Shutterstock, Inc

Ganesha and Lakshmi

There are numerous Hindu deities, too many to discuss in this brief chapter, however, there are a few such divine beings that need to be noted in order to come to know Hindu sculpture. Brahma, Vishnu, and Shiva are the three most prominent of the immortals. Brahma is the Supreme Creator, Vishnu is the Creator and Destroyer, and Shiva is the Transformer. These three deities have many unique sects of Hinduism that are devoted to the principles represented by these three gods. In addition, there are many representations of Ganesha, the Lord of Success; Krishna, the ninth avatar of Vishnu; Rama, the Supreme Protector of Vishnu; and Lakshmi, the Good Luck Goddess, to mention just a very few.

DRAWING PROJECT

Anthropomorphism is prevalent in Hindu sculpture as most prominently witnessed in the representation of Ganesha. The elephant headed deity is just one of a myriad of such manifestations in the Hindu tradition. Do some research in the library or through the internet on the pantheon of Hindu gods, goddesses, and demons. Using these as a template, create, on paper, with whatever drawing tools you enjoy using, an anthropomorphic deity of your own making.

Chapter 15

Aztec Sculpture: The New World

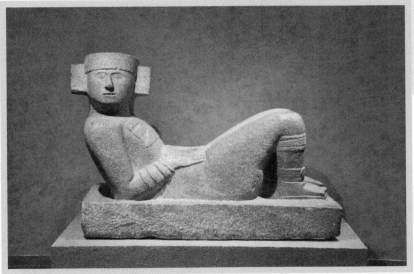

Aztec Chacmool - Mexico City

© jejim/ Shutterstock, Inc.

Chacmool is the term used to describe a sculpture of a figure whose back is on the ground and whose legs are pulled inward and whose head and back are raised upward. The stomach of the figure is used as a place for offerings during rituals or, perhaps, used as part of a human sacrifice ceremony. The Chacmool above is an Aztec creation. Most likely, chacmool is an ancient Mayan word for mountain lion. Chacmools have primarily been found in Mexico, particularly on the Yucatan Peninsula not far from the Mayan temple complex at Chichen Itza.

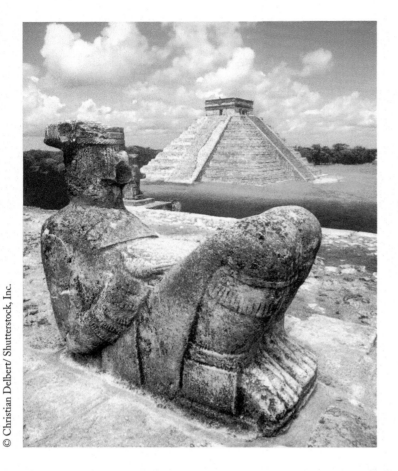

© Christian Delbert/ Shutterstock, Inc.

The Aztec tradition of stone sculpture has its roots in the ancient Olmec culture that exist-ed over 2500 years ago. The large sculptural heads are the most recognizable remnants of the Olmec people but their influence can be felt in the subsequent cultures of Mexico and Central America.

Prior to European contact with the peoples of Meso-America, the Aztec had a vibrant soci-ety which was centered in present day Mexico City, Mexico. The Aztecs used stones of all sorts to carve small scale deities or in the con-struction of major architectural wonders. Rit-ual icons, historical events, personages of the time, and indigenous fauna were captured in stone by the Aztec sculptors.

At the heart of the Aztec empire was the Tem-plo Mayor or the Major Temple located in

Olmec Head

© Paulo Afonso/ Shutterstock, Inc.

the Aztec capital of Tenochtitlan in present day Mexico City. The Templo Mayor stood high above the lowlands of Tenochtitlan and had two stepped pyramids located on the man-made plateau erected by the Aztecs.

The chacmool may very well be one of the earliest of the Aztec sculptural styles. The Aztecs used a range of materials to carve their sculpture from volcanic rock to jade stones. The Aztec Empire built their city of Tenochtitlan after a journey from their ancestral home of Aztlan. They were led in their quest by their faith in their god Huitzilopochtli. Their home of Tenochtitlan, by the late fifteenth century, was one of the most populated cities on the planet. They were a powerful military, cultural, and political empire until 1519 and contact with Spanish conquistadors.

Temple of the Sun at Tenochtitlan

© Serafino Mozzo/ Shutterstock, Inc.

© Marzolino/ Shutterstock, Inc.

Spanish conquistadors fighting against central-American natives. Created by De Bry, published on Magasin Pittoresque, Paris, 1842

Conquistadors or conquerors were Spanish soldiers sent to the New World to find gold and to conquer the indigenous peoples of the Americas, particularly in present day Mexico and Peru. Hernan Cortez was the Spanish Conquistador who led the mission to defeat the Aztec Empire and claim the territory for Spain.

STUDIO PROJECT

Using internet resources, research Aztec stone sculpture, as well as any information on the Aztec capital of Tenochtitlan. Using whatever sculpture materials you may have available: clay, paper mache, balsa wood, stone, or even a bar of soap; begin to create your own version of an Aztec god. Pay careful attention to the stylistic motifs of Aztec sculpture and to the purposes or functions of the deities that you have researched. Use that information to inform your sculpture.

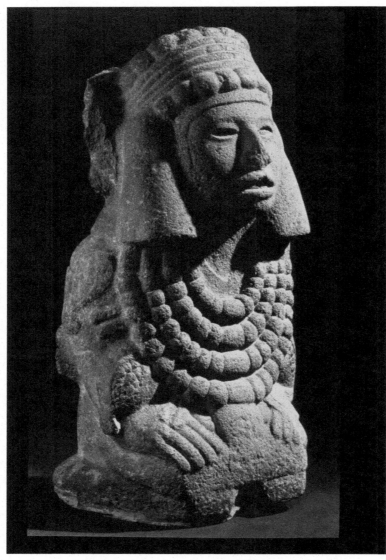

The Goddess Chalchihuitlicue, found in the Valley of Mexico, 1300-1500 AD (stone), Aztec / Musee de l'Homme, Paris, France / Bridgeman Images

The Goddess Chalchihuitlicue, found in the Valley of Mexico, 1300-1500 AD (stone), Aztec / Musee de l'Homme, Paris, France.

Chapter 16

The Great Wave of Kanagawa by Hokusai

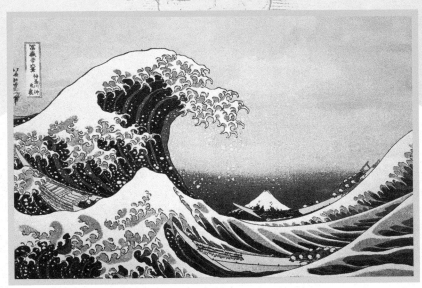

The Great Wave of Kanagawa, 1832, by Katsushika Hokusai (1760–1849), ukiyo-e style woodcut, Japan, 25.7 x37.8 cm. Japanese Civilisation, 19th century. / De Agostini Picture Library / G. Dagli Orti / Bridgeman Images

The Japanese color print was a popular art form that developed in the middle of the eighteenth century in the Edo Period in Japanese art history. These prints had two main manifestations: that of the Figure Prints which had its apogee in the 1790s and that of the Landscape Prints which reached its highest development from 1820 to the 1850s. It was preceded by the black and white print from about 1700 which was characterized by line drawing of a very fine order.

© cowardlion Shutterstock, Inc.

Statue of Shogun Ieyasu at Toshogu Shrine, Nikko, Japan

As it was a popular art form, the color print was originally viewed as of lesser importance by devotees of classic Japanese art, much of which had its roots in Chinese painting. Over time and due to the popularity of prints in Japanese culture, painters of the traditional schools also began to use their skills to produce color prints. The commercial success of the color print industry was a hindrance to the acceptance of color prints as a fine art by the elite art collector in Japan at that time.

Color print making was primarily centered in Edo or present day Tokyo. Edo was the capital of the Tokugawa Shogunate from the early 1600s until the late nineteenth century.

An important part of the Tokugawa system for controlling the independent and rebellious tendencies of the daimyos, regional lords, was to require every daimyo and his army of retainers, to reside in Edo alternately with residence in his home domain. Accordingly, there were usually tens of thousands of retainers in Edo at any given time. These retainers, as well as the merchant class, were the consumers of the color prints, as well as patrons of the Kabuki theatre and Sumo wrestling tournaments. When they traveled from Edo to their respective home provinces, these samurai took many of these color prints home with them.

Kuniyoshi Utagawa (1798-1861) color woodblock print of Sanada Yoichi Yoshitada dressed for the hunt.

Kabuki is a form of popular theatre that is characterized by flamboyant costumes and dramatic and colorful action. The origins of Kabuki are in Edo at the start of the Tokugawa Shogunate although some aspects of Kabuki have roots in the more ancient and traditional Japanese Noh theatre. The actors of the Kabuki theatre were popular subject matter for color print artists.

These colorful prints are sometimes referred to as Ukiyo-e or art of the floating world. This term refers to the urban entertainment lifestyle popular in Edo during the Tokugawa reign.

The Great Wave at Kanagawa is one of the thirty-six views of Mt. Fuji by Katsushika Hokusai in the early 1830s. Hokusai is perhaps the most well-known name associated with Ukiyo-e prints and his image of the Great Wave has been reproduced so often is has become a prevalent icon of Japanese art internationally. The dynamic tension of the soon to be crashing wave and the strenuous efforts of the oarsmen in their desperate attempt to avoid destruction frame the steady and eternal presence of the sacred site of Mount Fuji.

WRITING PROJECT

After close examination of Hokusai's Great Wave Ukiyo-e print, write a short story as a contemporary narrative inspired by the action found within the print. Once written, this narrative may serve as a basis for the creation of a series of illustrations that refers back to the newly written text.

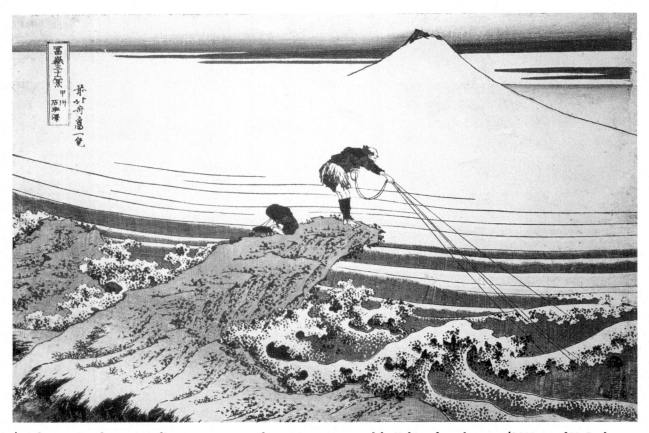

'A Fisherman Standing on a Rocky Promontory at Kajikazawa in Kai Province', by Hokusai from the series '36 Views of Mt.Fuji', pub. c.1830-31

'A Fisherman Standing on a Rocky Promontory at Kajikazawa in Kai Province', from the series '36 Views of Mt.Fuji', pub. c.1830-31, (oban size, yoko-e - horizontal format, colour woodblock print), Hokusai, Katsushika (1760-1849) / Christie's Images / Photo © Christie's Images / Bridgeman Images

Chapter 17
Dogon Art

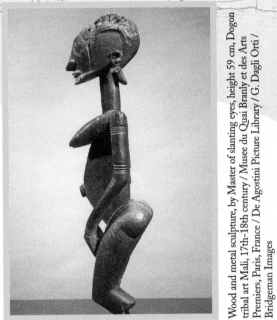

Wood and metal sculpture, by Master of slanting eyes, height 59 cm, Dogon tribal art Mali, 17th–18th century / Musee du Quai Branly et des Arts Premiers, Paris, France / De Agostini Picture Library / G. Dagli Orti / Bridgeman Images

Ancestral Female, mid Nineteenth Century, Smithsonian Institution

There has existed in Africa myriad tribal peoples with diverse and disparate cultural and artistic traditions. I have chosen the Dogon people as an exemplar of African art not because of any hierarchy in quality or significance as regards African art history but, almost solely because of my familiarity with the ritual sculpture of the Dogon people. The Dogon reside primarily in present day Mali and they are renowned for their carved wooden sculpture as well as their wooden masks used in ritual dances.

Dogon sculpture, such as the sculpture above, is very much part of their religious practices and ancestor worship. According to the Smithsonian Institution, this female ancestor statue "refers to Satimbe, the female ancestor who discovered masking and from whom men took the masquerade for male use. Images of Satimbe are carved as superstructures on certain masks. Another female character in Dogon mythology is Yasigine, the older sister of masks. She is associated with the women's groups that provide food and drink for the masquerade performers and may be referenced in art objects."

The Dogon live primarily in Mali, in West Africa. The topography of this part of Africa has informed and influenced the life ways and cultural practices of the Dogon. With a current population of over 300,000 the majority of the Dogon people live along the Cliffs of Bandiagara near the Niger River. These cliffs and the sandstone of the surrounding area are the site of most Dogon villages and the natural materials in that area have been used for centuries by the Dogon to shape their unique architecture.

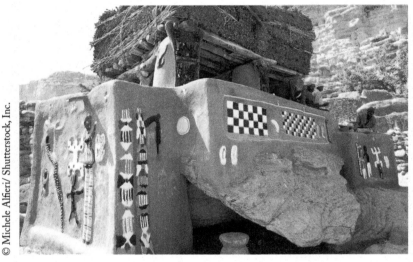

© Michele Alfieri/ Shutterstock, Inc.

Men are resting in the shadow waiting the beginning of the meeting in the Toguna (typical meeting house) on December 30, 2009, Ireli, Mali.

The Cliff of Bandiagara is a UNESCO World Heritage Site and the approximately 300 Dogon villages in the region contain unique architectural structures which integrate into the natural environment. The site includes residences, granaries, sanctuaries, and community or public meeting places called Togu Na. The ancient practices of the Dogon continue in these villages, such as ceremonial and ritual dances, festivals, and ancestor worship.

Dogon ritual and religious practices are multifarious and difficult to understand but, is principally expressed through ancestor worship. Observances of deaths and the anniversaries of the deaths of ancestors are marked by ritualistic dances that are commemorated with the use of ritual masks.

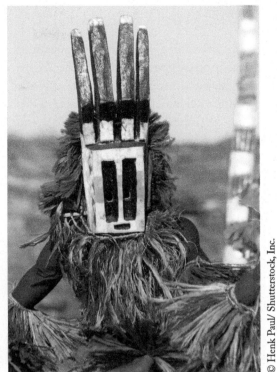

Dogon dancer with mask, representing a deer.

© Henk Paul/ Shutterstock, Inc.

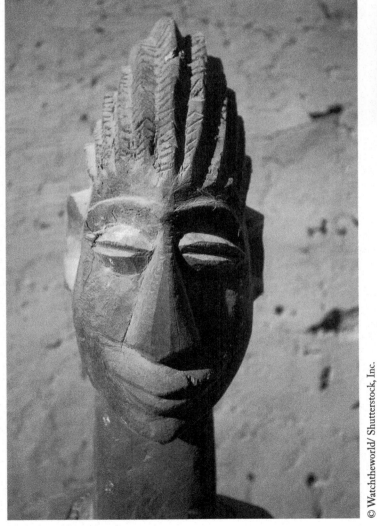

Dogon Ancestral Mask, Mali

© Watchtheworld/ Shutterstock, Inc.

Ancestor worship, such as that practiced by the Dogon, is the custom of revering the ancestors of a people. This type of veneration maintains the deceased as existing members of a family, a village, and of a tribe. The essence or life-force of the ancestor is considered to have spiritual power.

RESEARCH PROJECT ...

Using web-based museum resources such as the Smithsonian Institution's National Museum of African Art and other sites devoted to the Dogon people, research the ritual art and practices of the Dogon. Pay particular attention to the belief system of the Dogon and note similarities and differences between your own spiritual beliefs and those of the Dogon. In a 750 word essay, describe what you found in your research about the Dogon's spiritual practices and how the geography of the region in which they live may have contributed to their religion and rituals.

Chapter 18

El Greco: The Age of the Inquisition

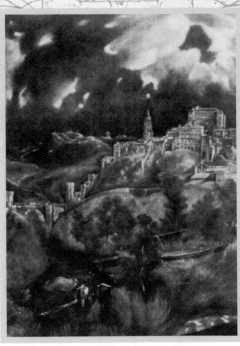

© Corel

El Greco, View of Toledo

El Greco, born on the island of Crete in 1541 as Domenikos Theotocopoulos, died in Spain in 1614. Little is known of his youth in Crete, which at the time was under Venetian rule, but, it is known that in 1570 he was living in Rome. He was certainly influenced by the art he saw in Rome and Venice including the work of Michelangelo, Titian, and Tintoretto. Few paintings from his life in Italy exist and he relocated to Toledo, Spain in 1577 to complete a commission of the altar piece of the church of San Domingo el Antiguo. He spent the remainder of his highly productive life in Toledo.

His success with his first commissioned Altar piece led to many others including his most famous Altar painting, The Burial of Count Orgaz in 1586-8.

The elongated figures of this masterful painting bear witness to the death, burial, and welcoming to heaven of Count Orgaz. The large and spiritually charged work of art is a testament to El Greco's esteem by the Catholic church officials in Toledo and to his position as one of the premier artists of his time in all of Spain. He produced numerous portraits of the powerful church officers as well as of the hierarchy of society in Toledo, Spain.

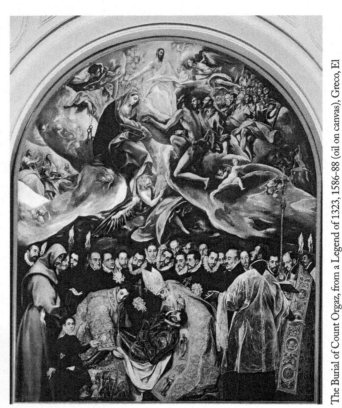

The Burial of Count Orgaz

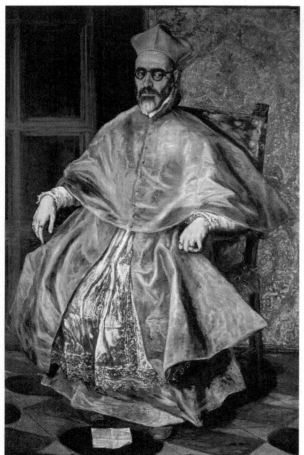

Cardinal Fernando Niño de Guevara by El Greco 1600-1604

In 1478, the Catholic Church in Spain instituted the Tribunal of the Holy Office of the Inquisition commonly known as the Spanish Inquisition. In 1492, the Tribunal proclaimed an edict that all Jews and Muslims convert to Christianity or be expelled from Spain. El Greco's thoughts on the role of the Inquisition cannot be known but, his work testifies to his close working relationship with those who carried out the work of the Tribunal in Toledo, including his portrait of the Grand Inquisitor of Spain Fernando Niño de Guevara.

El Greco's magnificent painting of his adopted home, View of Toledo, is one of the masterpieces of European art and certainly his most celebrated landscape painting. The work takes a picture perfect perspective of his beloved city and is a unique rendition of the objective reality of the cityscape before his perceptive eyes. Many of the landmarks captured by El Greco remain today as part of the vista of Toledo.

View of Toledo, Spain today

Christ in the Garden of Gethesmane is attributed to the studio of El Greco and is one of his great sweeping biblical narrative paintings. Owned by the National Gallery in London, the painting portrays the Christ, accompanied by a few apostles asleep on the left side of the canvas and the figure of Judas on the right side with a number of soldiers. An angel dominates the left side of the painting and appears to be offering Christ a chalice.

There is an intensity in El Greco's paintings that expresses strong emotion, deep spiritual and religious passion, and an originality of style rarely matched in his own days and since. The paintings, in

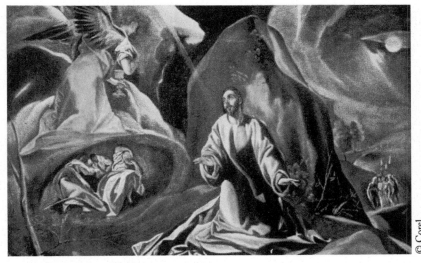
Christ in the Garden of Gethesmane

retrospect, appear to be harbingers of much more modern forms of realism and expressionistic representations of the human figure. This aspect of his art has elevated him beyond his time and place and positioned him as an inspiration to many nineteenth and twentieth century artists.

DISCUSSION PROJECT ·

Using El Greco's View of Toledo as a starting point, discuss in a small group the elements of this painting: the possible time of day, the artist's perch from which he envisioned this work, the possible symbolism of the weather, the time period in which the work was completed, and the role of the Spanish Catholic church in the late sixteenth century. What do you feel the overall tenor of the painting is?

Chapter 19

Self Portrait by Rembrandt: The Dawn of the Modern Era

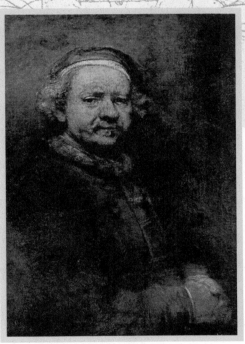

Rembrandt van Rijn Self Portrait

© Corel

The Dutch painter Rembrandt van Rijn was born in 1606 in Leiden. In 1624 he lived in Amsterdam and studied with the artist Pieter Lastman. Either due to the influence of Lastman or because of his own predilections, Rembrandt adopted a highly dramatic painting style that utilized theatrical lighting and lustrous finishes that have become the hallmarks of a Rembrandt painting. By 1631, Rembrandt was entrenched in Amsterdam where he completed numerous self-portraits, as well as becoming the leading commissioned portraitist

of his day. The early 1630s would prove to be one of the most fertile and productive times in his career. It was at this time that he married Saskia van Uylenburch whom he portrayed in numerous loving likenesses.

Unfortunately, great triumph and success came to Rembrandt in 1642, as well as great loss. This was the year he painted what many believe to be his masterpiece, The Night Watch and, it was also the year that his beloved Saskia died.

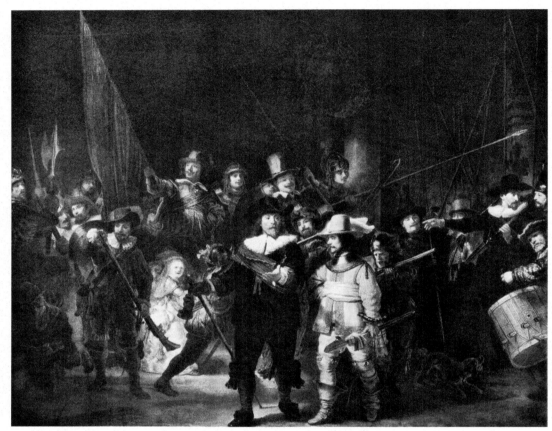

The Night Watch

Not long after Saskia's death, Rembrandt's commercial success began to ebb and he turned to depictions of biblical scenes as he turned away from commissioned portraiture. At the same time as he used his prodigious talents to create deeply moving and powerful paintings of a religious nature he began drawing, making etchings, and painting landscapes.

After decades of ignoring his financial realities, Rembrandt was nearly destitute by 1656. By 1660 he had to relocate to a poor area of Amsterdam. While remaining a respected artist and citizen he was still much reduced in his resources. However, this was also a time of creative vigor for Rembrandt and he produced one of his finest paintings, The Syndics.

Rembrandt van Rijn (1606 -1669) "Syndics of the Draper's Guild," 1661-2

Etching is a form of printmaking which Rembrandt found particularly appealing. He would take a thin copper plate which he covered with a thin ground mixture of asphalt, wax, and resin. Using sharp needle like tools, Rembrandt would draw his images into the ground leaving thin lines of the copper exposed. The copper plate is then placed in a diluted acid bath where-in the acid etches into the exposed areas of the copper plate. Once removed from the acid, the ground is removed from the surface of the copper plate leaving an incised and grooved plate ready for ink to be wiped into the recessed areas etched by the acid. At this stage a damp piece of paper is laid upon the plate and the plate and paper are rolled through the press and the ink is squeezed out of the recessed, etched areas of the copper plate onto the paper.

The range of Rembrandt's work, from commissioned portraitist to deeply emotional and powerfully evocative painter of biblical scenes, from delightful playful self-portraitist to deftly skilled printmaker, set him apart from the other fine painters and artists of seventeenth century Amsterdam.

RESEARCH PROJECT

Using library resources, review the life and times of the artist Rembrandt van Rijn. In particular, familiarize yourself with his biography and begin to formulate connections between the phases of his life and his artistic output. Using the self-portrait at the start of this chapter as a comparison, find on the internet other Rembrandt self-portraits from different ages in his life. Compare and contrast these two self-portraits. Write a short five hundred word essay that unfolds your thoughts on the Rembrandt self-portraits you chose.

Chapter 20

Liberty Leading the People: The Age of Enlightenment

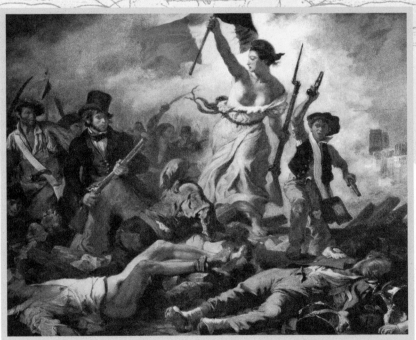

© Oleg Golovnev/ Shutterstock, Inc.

Eugene Delacroix created one of the most iconic paintings in French art history, his depiction of the July 1830 uprising in Paris, France that over threw the Second Restoration government and Charles X, the then King of France. The artist was a witness to the revolution and he used his extraordinary skills as a Romanticist painter to elevate the violence in the streets of Paris into one of the great allegorical paintings in history. In September of that same year, Delacroix began feverishly painting his patriotic work of art and by the end of the year he had completed his masterpiece.

Delacroix, as he had done with earlier epic paintings in his oeuvre, produced many preliminary sketches of his overall composition and of the details he wished to incorporate into his overall design. His use of a classical triangular composition brings to the forefront of the action Lady Liberty leading the enraged rabble to victory.

Liberty is personified as a fearless woman of the people wearing the Phrygian cap and she carriers the tri-color flag of the French nation. She is an allegory of liberty yet, she exists within the picture frame of Delacroix's painting as a flesh and blood person in the real action of the day.

An allegory is a pictorial or literary device that is used to symbolize or represent a moral or political ideal or concept. In the case of Delacroix's painting, the idea of liberty is represented in the figure of a dynamically active woman in the lead of the common people of Paris in pursuit of their ideal: liberty. Of course, many artists have used allegory as the basis of the content of their art. Here is Thomas Coles painting of Youth which is part of his masterful nineteenth century American painting series the Allegory of the Voyage of Life painted in 1842.

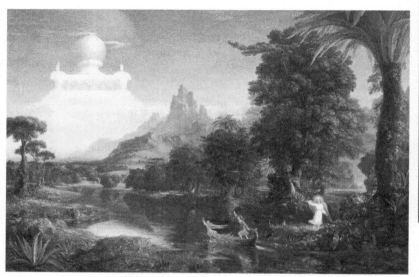

The Voyage of Life: Youth, 1842 (oil on canvas), Cole, Thomas (1801-48) / National Gallery of Art, Washington DC, USA / Bridgeman Images

READING PROJECT ...

Since the allegorical figure of Liberty is the bold central element in Delacroix's painting, it may be instructional to both research works of art, such as those by Thomas Cole's, and to find and read allegorical literature. George Orwell's Animal Farm is a fine example of twentieth century allegorical literature. The Lion, the Witch, and the Wardrobe by C. S. Lewis is another fine example of accessible allegorical literature. Choose a work of fiction or poetry that you feel best exemplifies the concept of allegory and write a one page assessment of why your selection is an example of allegory.

Chapter 21

The Oath of the Horatii by Jacques-Louis David, 1784: Neo-Classicism

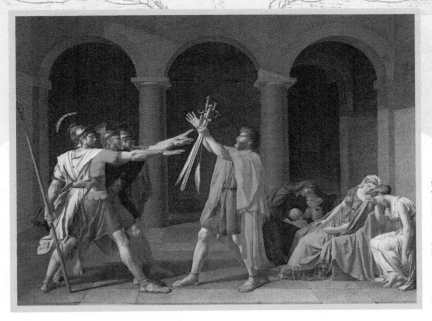

The Oath of Horatii, 1784 (oil on canvas), David, Jacques Louis (1748-1825) / Louvre, Paris, France / Giraudon / Bridgeman Images

This epic canvas stretches out in the Louvre at over ten feet in height and over thirteen feet wide and is one of the most significant works of art in French history created by the master painter, educator, and museum director Jacques-Louis David. The Administrator of the Royal Residences in Paris, France commissioned David to paint this classical scene in 1784. The story of the Horatii is set in the cities of Rome and Alba in 669 bce and is a drama where three brothers, the Horatii, are to battle three other brothers, the Curiatii, in order to settle disputes between the two city-states. The moment captured in the

painting is when the three Horatii brothers give their oath to their father to fight the Curiatii to the death.

The scene set by David is actually not an event from any historical record but, a device set by the artist to illustrate his own conceptions of loyalty and patriotism. David was familiar with the playwright Pierre Corneille's tragic drama, Horace. Corneille based his play on the account of the Horatii by Titus Levy. The play premiered in 1640 and it is most likely a contemporaneous production in David's time that inspired the theme of the painting.

Jacques-Louis David was born in 1748 in Paris and his genius as a painter was discovered when he was a young boy. He was a success from the outset of his career and he was not only a brilliant portraitist but, he was also the Director of the Louvre and Napoleon's court painter and after the defeat of Napoleon, an exile from France.

Jacque-Louis David was a master of taking classical stories and events from Greek and Roman history, such as in the Oath of the Horatii, and using those dramatic scenarios to reflect the political tone of his time. The last decade of the eighteenth century was a time of great violence and revolt in France and the Reign of Terror played a significant role in David's selection of subject matter.

Throughout the revolution, the Reign of Terror, and the establishment of the Republic of France, Jacque-Louis David continued to be a Royalist and academic painter of neo-classical tastes. In late 1804, Napoleon Bonaparte became the Emperor of France and David's allegiances were focused on serving Napoleon's court.

In 1814, Napoleon's reign came to an end and David's reign as First Painter to the Emperor also ended. In 1816, David was exiled to Belgium where he died in 1825.

© Corel

Madame Recamier, 1800

In 1792 when France becomes a republic through revolution and in 1793 King Louis XVI is executed and in June of that year the French Constitution is established and on September 5th of 1793 the Reign of Terror begins and lasts for nearly ten months. Political rivals in the revolution battled each other and the Reign was characterized by considerable executions of those accused of being enemies of the revolution.

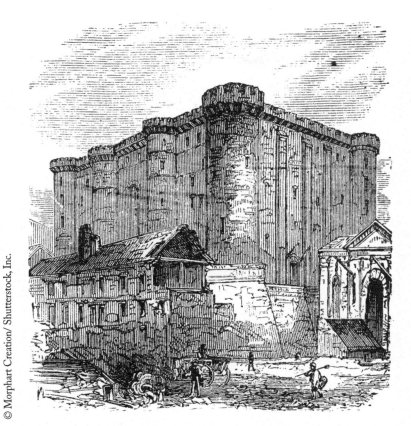

The Bastille or Bastille Saint-Antoine in Paris, France. Vintage engraving. Old engraved illustration of the French fortress-prison in 1890.

Neo Classicism is a term widely used in art history to describe the attention that late eighteenth and early nineteenth century artists, writers, architects, and composers paid to classical antiquity. The example set by Renaissance artists in their interest in Classical Greek models and ideals was revived by artists such as Jacques-Louis David. Archaeological finds, such as those at Pompeii, brought forward additional examples of harmony and ideal proportions as set forth in antiquity. The Greek and Roman art and reproductions of those classical models were brought to Paris and used as guides for study in the art academies of David's day.

Eglise de la Madeleine. Madeleine Church was designed in its present form as a temple to the glory of Napoleon's army.

The Death of Socrates, 1787

Considered by many to be David's most neoclassical of paintings, the Death of Socrates portrays the story of Socrates suicide just as he accepts the chalice of hemlock. The composition is highly controlled and balanced, the unemotional and dispassionate demeanor of Socrates as he declares his belief in a rational and ethical life in spite of his choice to drink the hemlock is in keeping with the ideals of neoclassicism in art and life. The hard edged geometry of the interior architecture, the arrangement of forms as if it were a tableau carved on a Greek Temple, and the coolness of the scene itself are hallmarks of the elegant style refined by David over his impressive career.

RESEARCH PROJECT ..

Jacque-Louis David lived through the end of the reign of Louis XVI, the French Revolution, the Reign of Terror, the rise and fall of Napoleon, and exile in Belgium at the end of his life. Using internet and library resources, examine the pivotal events that he lived through and participated in and note the specific works of art he created during each of these phases in his life. Create a timeline of events that starts with his early life and schooling and through to 1825 and his death. Match, on the timeline, the critical moments in his biography with the critical events of his time and with the seminal works of art he created that flow along the same chronology.

Chapter 22

The 3rd of May 1808, painted by Goya in 1814: Romanticism

Francisco de Goya y Lucientes was born in Fuendetodos, Spain on March 30, 1746.

© Neveshkin Nikolay/ Shutterstock, Inc.

G oya began his serious artistic study in the Madrid studio of the highly successful academic and court painter Anton Mengs. In the late 1760's Goya was a respected tapestry design painter for the Royal Tapestry Factory. His masterful and playful designs brought his talents to the attention of the Spanish royal family and he gained membership in the Royal Academy of Fine Art. It was at this time, during the reign of Charles IV, that Goya reached his height of popularity within the world of the Spanish court. His portraits of the royal family made him one of the legendary painters within the long lineage of Spanish court

painters. Later in life, after an illness that left him deaf, he became more introspective and alienated from court life and he began experimenting with more socially relevant painting and printmaking content.

After the French, under Napoleon's rule, invaded Spain in 1808, Goya's world and art turned upside down in relationship to his earlier life-style and his work as a producer of acceptable tapestry designs and royal portraiture. Even after the restoration of the Spanish court in the aftermath of the war with the French, Goya continued to paint portraits of Spain's elites, although he became increasingly distant from the royal family. His anguish over the realities of life in Spain under the rule of Ferdinand VII and his own inner turmoil, led him to further exploration, through his artworks, of the demons that swept through his consciousness. In May 1824 he left Spain for Bordeaux in France and remained there until his death in 1828.

His life and work remain as an inspiration to artists, social activists, and connoisseurs to this day.

The Third of May, 1808 was painted by Goya in 1814 and it depicts the battle between Napoleon's army and the beleaguered Spanish troops that took place in the city Median del Rio Seco in Spain. Both sides in the battle

Statue of Goya in the center of Zaragoza, Spain

lost many soldiers but the Spanish sustained devastating loss of life and this highly dramatic image shows the Spanish fighters being executed by Napoleon's well trained and merciless professional legionnaires. Some have described the central figure in white with his arms raised as a symbol of Christ. Whatever interpretation is employed, it is certain that Goya chose to mythologize the plea of the Spanish during this horrible battle scene and to use the man in the white shirt as a symbol of the desperation and, yet, hope of the common people of Spain.

Goya had been working in what might be described as a Romanticist approach to art since the time of the battle at Median del Rio Seco in 1808 and before 1808, His Los Caprichos series of prints were a deeply disturbing artistic response to the Spanish war with France. From about 1808 to 1810, he began his even more unnerving series of prints, Disasters of War, that are, perhaps, the most powerful indictment against war ever produced by such a famous and once courtly painter.

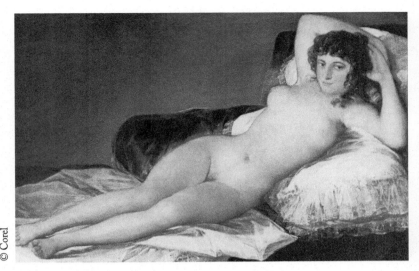

The Naked Maja

© Corel

As with other artists of the time period, Goya tended to comment on the political and social upheaval of the early 19th century with a mix of observations of objective reality and an ironic eye. Artists across Western Europe also focused their attention on the victims of the atrocities of the ruling class and of war. The period of the late 18th and early 19th centuries was a time of scientific inquiry, global exploration and expansion of empire, as well as an examination of the expressive content of the artistic imagination. Goya supported enlightened thinking against oppression and his life and career suffered the consequences of his idealism. His final works have little in common with those of his contemporaries in France and Spain and had almost no impact on the generations that immediately followed. In fact, they remained little known until the early twentieth century.

Ferdinand VII returned to power in 1823, letting loose a brutal purge of Liberals, who fled to France in legions to escape persecution. Although Goya's political sympathies were with the Liberals, he was treated with generosity by the king and was granted permission to take the waters in Plombières in France for his health. Distrustful of the situation, the artist took advantage of the leave to join his friends in the thriving Spanish expatriate community in Bordeaux, where he spent the last four years of his life.

RESEARCH PROJECT ·

Goya certainly suffered the consequences of his artistic idealism and his political activism through his art. Research into the art and lives of other artists who have suffered for their artistic freedom of expression, particularly those artists who have commented on societal and political ills and who have been artist/activists. The contemporary Chinese artist Ai Wei Wei is an example of an artist who has endured attack from authorities, much like Goya did, for the realization of his artistic vision. Write a 750 word essay discussing the art and artist that you have chosen.

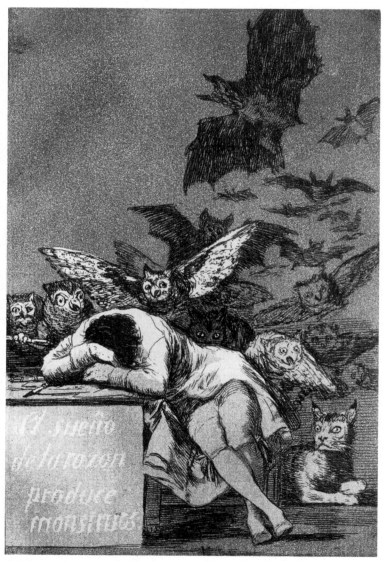

The Sleep of Reason Produces Monsters, from 'Los Caprichos'

The Sleep of Reason Produces
Monsters, from 'Los Caprichos'
(engraving) (b/w photo) (see also 81662), Goya y Lucientes, Francisco Jose de (1746-1828) /
Bibliotheque Nationale, Paris, France / Bridgeman Images

Chapter 23

Water Lilies by Claude Monet: Impressionism

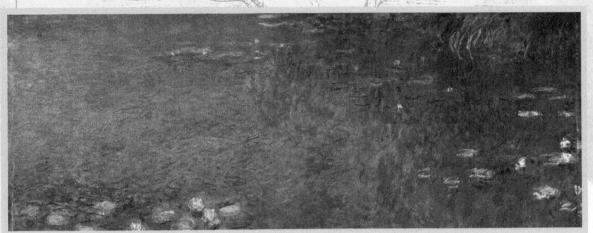

Waterlilies: Morning, 1914-18 (centre right section),
Monet, Claude (1840-1926) / Musée de l'Orangerie,
Paris, France / Giraudon / Bridgeman Images

Claude Monet was known for many famous paintings, including Impression: Sunrise which many believe to be where the term Impressionism comes from, but, perhaps his most dramatic and impressive work is his triptych of his own water lily swathed pond at his home in Giverny, France, not far from Paris. The painting, unlike any other before it, surrounds the viewer with the sensations which the artist felt and recorded. The paintings, as per the intentions of the artist, are exhibited as a curved piece, embracing the visitor into the work of art.

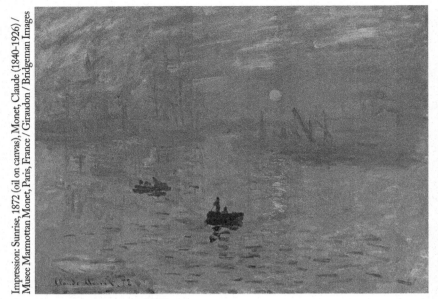

Impression: Sunrise, 1872 (oil on canvas), Monet, Claude (1840-1926) / Musée Marmottan Monet, Paris, France / Giraudon / Bridgeman Images

Impression: Sunrise, 1872

Impressionism was an art movement begun in approximately 1863 in France. I artificially date the movement from the moment of Edouard Manet's painting Dejeuner Sur L'herbe which caused quite a stir in Parisian art circles. While Impressionism is best represented by artists such as Claude Monet, with his almost scientific study of light and color and an attention to capturing the shifts in daylight and mood in the scenes he painted while outdoors in the landscape, the artists grouped as Impressionists are a varied lot. The exhibiting of Monet's painting, Impression: Sunrise, in a group show in 1874 in Paris was the impetus for the journalist Louis Leroy to label all the artists in the exhibition Impressionists.

Monet was born in 1840 and died in 1926 and his life and work spanned an era of great change in the art world and societies across the globe. He grew up in the seaside town of Havre, France where he began his artistic career as a landscape painter. He was devoted to painting his scenes in the outdoors and this took him to rural areas of France as well as to urban centers to capture the light and color of the focus of his energies. After much study and two years in the French army serving in Algiers, he settled in Paris in 1862 where he met artists of like-minded sentiments and aesthetics. It was here that he fell in with artists such as Renoir, Pissarro, and Sisley, all of whom would become icons of French Impressionism. In 1883 he created a home for himself and his family at Giverny along the Seine River about fifty miles from Paris. It was here that many of France's most famous artists came to visit with the master and to dine at his table. In the last decade of the nineteenth century he completed a number of series of paintings that each captured the effects of light and the time of day on a single subject. His haystack series is an excellent representation of his fixation on variations on a theme.

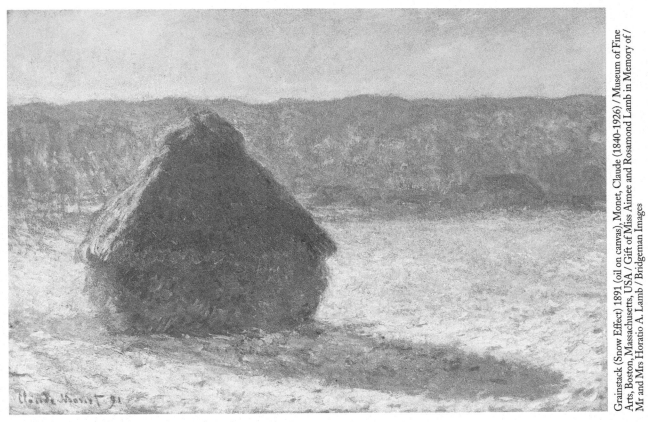

Grainstack (Snow Effect) 1891 (oil on canvas), Monet, Claude (1840-1926) / Museum of Fine Arts, Boston, Massachusetts, USA / Gift of Miss Aimee and Rosamond Lamb in Memory of / Mr and Mrs Horatio A. Lamb / Bridgeman Images

Claude Monet's Haystacks, Snow Effects, 1891

In the new century, Monet focused most of his attention on the pond on the grounds of his beloved Giverny. It was here that he created a special studio at Giverny to work on the large canvases that would become hallmarks of Impressionism, as well as harbingers of the abstract painting styles that would dominate the twentieth century art world.

© Pack-Shot/Shutterstock, Inc.

The Village of Giverny is located on the Seine River about fifty miles from Paris and is considered a gateway to the Normandy region of France. It was here, in this quiet and bucolic setting that Monet set up his home, his studio, and a place for artists from across Europe and the Americas to congregate. Monet's house and gardens are now open to the public and the same fresh bursts of brilliant color found in Monet's paintings can be experienced in the interiors of Monet's home and in the brilliant gardens that inspired him.

STUDIO PROJECT

The Impressionists, such as Claude Monet, used the basic principles and elements of art to create vibrant and now, highly cherished works of art. With care and thoughtfulness, select a place near where you live that you believe captures the kind of effervescence that you think might have drawn the attention of an artist like Monet. Either bring a folding chair or use a bench or other existing seating place to do your outdoor color sketching, much as Monet might have done. Using a simple sketch pad and color oil pastels or color markers or color pencils, begin to capture the lines, textures, colors, forms, and light of the scene in front of you. Note the time of day, the direction from which the sunlight is coming and where the shadows within the landscape fall. Share your finished impressionistic drawings online or in class.

© Corel

Claude Monet, Poplars on the Epte 1891

Chapter 24

Self Portrait by Vincent Van Gogh: Post Impressionism

© Corel

Vincent van Gogh was born in 1853 in Zundert, Holland. His father was a Protestant pastor. Van Gogh began his academic training to become a minister but he left his schooling to become a poor itinerant preacher in 1878 in a poverty-stricken area of Borinage in Belgium. While destitute in Belgium in 1880 he turned his passions away from his religious fervor to becoming an artist. He remained a devotee to his art until his death in 1890. In the span of ten years he produced a large number of paintings and drawings while living in near starvation conditions. He sold just one painting during his lifetime.

In the early years of the 1880s van Gogh lived in the Netherlands where he was partially supported by his brother Theo. He and Theo kept up a prodigious correspondence during the last decade of Vincent's life and these letters provide great insight into the life and artistic intentions of the fervid artist. Van Gogh's paintings and drawings of the peasants in the neighborhood where he lived are some of the most moving of his oeuvre. At the end of this period of his life he lived in the city of Antwerp where he studied at the local Academy and it was in 1886 that he left Belgium for the then mecca for serious contemporary artists, Paris. It was here that he met and became friends with the artist Paul Gauguin whom he had a close but turbulent rapport with for the short few years they knew each other in France.

In Paris and through his travels in France, van Gogh's paintings matured and became more idiosyncratic. While being influenced by the Impressionists and the colorful Japanese prints he saw in the homes of fellow artists, van Gogh followed his inner muse and began ardently using bold colors and daringly using line and heavy paint strokes to create the style of art that would become known as Post Impressionism.

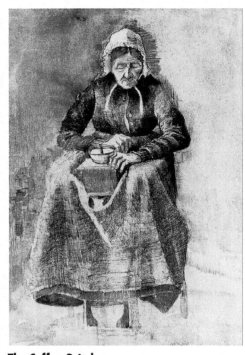

© Corel

The Coffee Grinder

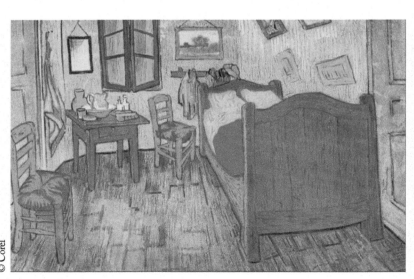

© Corel

The Bedroom

Paul Gauguin, like van Gogh, was an innovator of what has become known as Post Impressionism. His colorful life included a childhood spent partially in Lima, Peru, an early career as a stock broker, and his personal escape into the bohemian world of the artist in Paris and in the Brittany region of France and, for a short time, in the company of van Gogh in Arles, France. In 1891 he went to the south Pacific island of Tahiti where he completed some of his most famous paintings.

While in dire poverty and dealing with his emotional state of being, van Gogh moved to Arles, France in early 1888 where he feverishly painted over two hundred works of art. Paul Gauguin joined him in Arles for a brief time and together they created a new and intrepid style of painting that would come to epitomize the modernist life of the bohemian artist struggling to realize a personal vision of the world through painting.

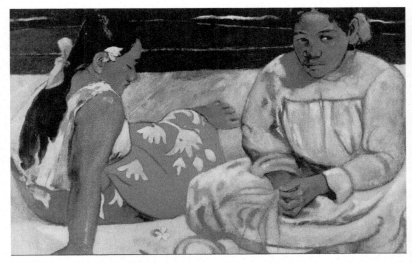

© Corel

Women of Tahiti by Paul Gauguin

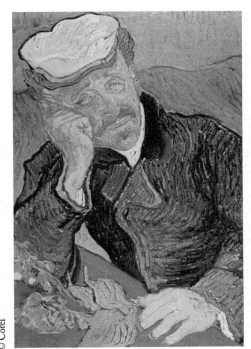

© Corel

Dr. Gachet

It was at this time that the troubled van Gogh, for what may have been reasons associated with his quarrels with Gauguin or delusions he had concerning his romantic interests in a woman, that he cut off a piece of his left ear. The self-portrait at the start of this chapter more dispassionately captures his observation of his disturbing act of self-mutilation. Shortly after this incident, he committed himself to an asylum in St. Remy, France where he continued to paint zealously. Some of his most famous works, such as Starry Night, now at the Museum of Modern Art in New York City, were generated at this time in his life. Late in this last decade of his life, he left the asylum in St. Remy and moved to Auvers-sur-Oise, France to be near his brother Theo who moved there with his new wife. Van Gogh lived with Dr. Paul Gachet and in the next two months in 1890, van Gogh painted with a fanatic enthusiasm. On July 29, 1890, Vincent van Gogh committed suicide.

STUDIO PROJECT··

Using Vincent van Gogh's famous painting, Starry Night, as a template, use bold and colorful markers on a heavy stock paper of a size of your choosing, create your own Post Impressionistic vision of the night sky. Actually spend some time star gazing on a clear night to get the sense of the night sky where you live. Allow yourself to freely and imaginatively capture the look of that night sky as well as your emotional experience and reaction to that night sky.

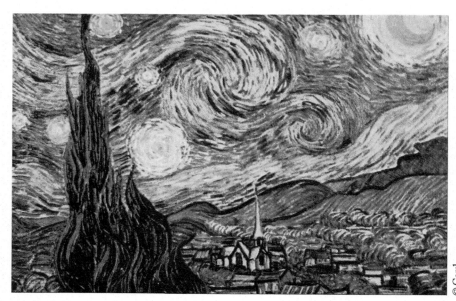

Starry Night

Chapter 25

Les Demoiselles d'Avignon by Pablo Picasso: Cubism

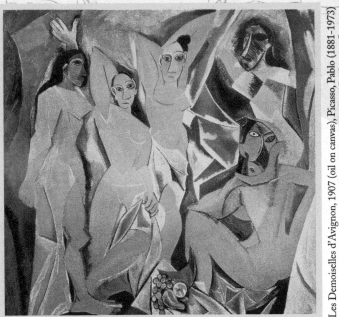

Les Demoiselles d'Avignon, 1907 (oil on canvas), Picasso, Pablo (1881–1973) / Museum of Modern Art, New York, USA / Giraudon / Bridgeman Images. © 2014 Estate of Pablo Picasso/Artists Rights Society (ARS), New York

Les Demoiselles d'Avignon, 1907

Pablo Picasso's seminal work of art, Les Demoiselles d'Avignon, was created in 1907 but not unveiled by Picasso to anyone for many months after its completion. The monumental painting is a profoundly unique and revolutionary work of art that, even today, is perhaps not as accessible to the general public as other master pieces of world art. Influenced by his encounters with African masks and sculptures, Picasso produced a portrait of five women in a picture plane fractured into myriad

pieces. It is almost as if the artist is capturing the dynamic of the transaction before him from all possible angles of vision. He has not only presented a picture of five static figures but a vigorous portrait that brings the two dimensional plane of the painting into the three dimensional world. Metaphorically, he has taken a flat rectangle and produced a cubic image or, as categorized by art historians, he made Cubism.

While the start of modern painting is a debatable question, without question, Picasso's Cubist period must be one of the main contenders for that recognition. Some may begin the modern era in painting with Manet's Dejeuner sur L'herbe and others may point to Goya's late black paintings, it is easy to look to Les Demoiselles d'Avignon as a truly exemplary modern work of art.

Besides the name Rembrandt, there is perhaps no other painter whose name is more synonymous with the life of an artist than Pablo Picasso. Born in 1881 in Malaga, Spain, his father was a painter and a teacher. He was a child prodigy and excelled at art at a very early age. At the age of fourteen, he and his family moved to Barcelona, Spain where he became the youngest student at the prestigious School of Fine Arts. At sixteen, he left Barcelona for Madrid, Spain to study at the Royal Academy of San Fernando. In just two years he outgrew the Academy's classical curriculum and moved back to Barcelona to go his own direction as an artist.

Cubism begins with the paintings of Pablo Picasso and Georges Braque, whose studios were close to each other and whose working relationship produced the first great movement of modern art in the twentieth century. As with Impressionism, the term cubism came from an art critic, Louis Vauxcelles who, in 1908, commented in a negative way about the work of Georges Braque. The early form of Picasso's and Braque's painting in the first decade of the twentieth century may be called Analytical Cubism and Picasso's later paintings as Synthetic Cubism.

What was to follow was a remarkable, if not the most remarkable career of any artist in the past 150 years. His legendary artistic transitions and revolutionary stylistic changes begins with his Blue Period and into his Rose Period and onto Cubism and his surrealist period and, throughout the many years of his innovations, he produced startlingly powerful icons of the human condition. He died on April 8, 1973 in Mougins, France.

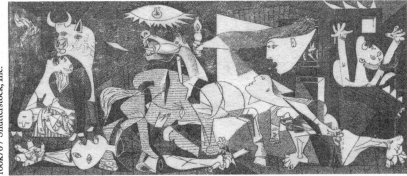

rook76 / Shutterstock, Inc.

Picasso was not just an artist, he was also a political activists and he used his art to make powerful statements about the injustices done to the people of Spain and in Europe during his life time which spanned both World Wars and the Spanish Civil War. His painting Guernica is his reaction to the bombing of Guernica, a Basque village in northern Spain in April 1937. Picasso captured the poignancy of the destruction reigned upon the village by German and Italian bombers.

While Picasso is rightfully remembered for his monumental and pivotal works of modern art, he was also a painter of portraits. From his early highly realistic drawings to his colorful synthetic cubist paintings of his wives, mistresses, and children, he captured the love, compassion, pain, sorrow, and melancholy of his sitters.

One of the many creative attributes that has made Picasso a household name was his deep curiosity and experimental tendencies with ideas and materials. While not the creator of the collage, he certainly was one of its greatest innovators. He, perhaps, did create found object sculpture and was a great avant-gardist when it came to sculpting in bronze, welded metals, and in stone and wood, as well. He was an extraordinary ceramicist and one of the foremost print makers of the twentieth century. Picasso tried his hand at every visual artistic activity he encountered during his lifetime.

BIOGRAPHY PROJECT ..

Pablo Picasso lived through some of the most defining events of the late nineteenth and twentieth centuries. His artworks maybe considered a window onto the revolutionary changes in Europe and beyond, including the upheavals of war. Research the life and times of Pablo Picasso and his diffreent periods of artistic modernization that he brought forth into the world. Select one time period in his life and a work of art that you feel is most emblematic of that chapter in Picasso's highly interesting life. Write a 750 word essay that connects the time in Picasso's life you have chosen, an artwork that is paradigmatic of that time in his life and the events that were happening in the world that Picasso lived in at that time.

Chapter 26
Georgia O'Keeffe: An American Original

Georgia O'Keeffe (1887–1986)
Music, Pink and Blue No. 2, 1918
Oil on canvas, 35 x 29 15/16in. (88.9 x 76 cm).
Whitney Museum of American Art, New York; gift of Emily Fisher Landau in
honor of Tom Armstrong 91.90
Photography by Sheldan C. Collins

"Happy who know that behind all speeches still the unspeakable lies"

Rainer Marie Rilke, the author of the above quotation, is certainly not the first nor is the last to suggest that behind the conventions of communication is a level of understanding shared tacitly. It is in this domain of shadows and obfuscated lights that the voices of artists emanate. Essences worthy of disciplined approaches lurk in the recesses of this "unspeakable." The manifestation of these essences through the

artist's incursions, at its most profound, is not a vision of fashionable diversions; rather, it is the celebration of the truly significant.

A leap out of the conventions of definable cause and effect and into the realm of the poetic, the mythical, and pure experience is a jump recognized by few and taken by even fewer. It is the celebration of Rilke's "unspeakable" and the leap into its unknown wherein the artist creates. By living through experience, not mere reflection, the artist joins hands with the "unspeakable" and dances a festive jig.

To understand the significance of this performance, a particular artwork by Georgia O'Keeffe is examined through the lingering impact on the conscious memory of this recorder. It may be noted that sharing the celebration of the art is limited by the absence of the art itself and it is hoped that this written co-creation will not somehow sacrifice the art for the words on paper.

Georgia O'Keeffe, a student of the renowned Columbia University art educator Arthur Dow, was taught "to fill a space in a beautiful way" (Heller, 126). This is a phenomenological approach to the act of painting. In following Dow's tenet, O'Keeffe was suspending belief in predictable and accepted standards of art. She bracketed off her action as a painter and used her intuitive reactions to the world of relationships that existed between her, the canvas, and the oil paint to produce the beautiful.

A Here and Now sense of the physicality of the art, as well as a connection with the sublime, resulted in striking non-objective imagery at a time when only a few Russian experimenters were seriously playing with the purity of form and color. O'Keeffe's paintings of 1913-1919, with their simplicity and directness of primary colors, produced a foundation upon which her art grew. The art glows with a non-judgmental aura which reflects a disciplined encounter with the blank canvas. In confronting the canvas with wide-eyed wonder, O'Keeffe revealed the mysteries of the absolutely subjective.

Her oil on canvas, Music: Pink and Blue of 1919, can be approached as a living, breathing construct, not just as a Hegelian "thing of the past." There is in this art a collapse of alienation. The art as a thing is disavowed, allowing its energies as an interactive force to emerge. The quality of the art is integrated into the life blood of the viewer. O'Keeffe's spirit of inquiry bridges the gap between the art as an object and the viewer as an outsider. The commodity of the art is reconstituted into the bosom of the personal history of the artist and the viewer.

The familiar bone structure of an O'Keeffe artwork is evident in the rectangular presentation of this painting, as is the cool blue expanse that wraps the bone China white of the circular form that dominates the picture plane. There is an allusion to space, as if one were traveling in slow-motion cinematography beneath the arches of an eroded landscape. Gliding effortlessly on a magic carpet, the inner world of the O'Keeffe is bridged. A link is made between the mortal spirit of the viewer and the spiritual elevation which the artist points to. A covenant is made between the artist and her audience. United they travel in search of a "daydream of elsewhere." (Bachelard, 62)

It is easy to enter the daydream of an O'Keeffe painting. This particular painting, Music: Pink and Blue, is not atypical of her highly charged work. It is inviting, much like a refreshing cool drink on a sweltering humid summer day. The quality that invites the viewer presents itself powerfully as the unfolding of a dry white rock formation. It gives the viewer an invitation to climb inside. O'Keeffe's creation becomes a dwelling place that encloses the dreams and reveries of the viewer's childhood and maturing experiences.

Daydreaming is an apt way to describe this O'Keeffe. A positive daydreaming, infected with a sense of wellness and protection. There is a warmth in the cool blues and whites that becomes a welcoming beacon within the familiar household that the art creates.

The French philosopher Gaston Bachelard wrote of this sensation of the familiar: "For the real houses of memory, the houses to which we return in dreams, the houses that are rich in unalterable oneirism, do not readily lend themselves to description." (13) The "unspeakable," the essential relationship of the viewer and the welcoming bosom of the familiar household of the art are secretively and seductively hiding within the mask of the deftly applied pigment. This O'Keeffe painting gives back to the viewer reveries of intimate vistas and in no certain terms allows an authentic voice to be revealed within the depths of the familiar hold of the art.

The surface of the dry white paint is marked sensually with pink highlights and cerulean shadows. A darker rose madder opens out from a twisted finger-like fold of bone and looks out quietly. It is an eye of wisdom peering out, an all-knowing projector of the intimacies shared between those who seek art for answers and those who create it for like purposes. Folded within the seams of the bone is this red marrow, this life-producing meat that sustains growth and allows for strength and vitality. Like Apollo spreading his golden rays, the eye of this painting shines with a heroic light. Youthful, vibrant, rich in life-giving cells, the courageous eye looks out and guides us to the core of the art. Yet, attached to this powerful and seductive circle of light and inviting womb of birth is a less Apollonian art. There is in the painting a touch of contrasting music as implied in the painting's title.

The contending lights and voices of cool blue and hot pink are like impulsive crashing sounds of Dionysian music. Nietzsche wrote of this elevated, mythic conflict between the lightful Apollo and the murky Dionysus:

> The two impulses, different as they are, were carried along side by side, generally in open opposition, provoking each other to ever new, more mighty births through which to perpetuate the war of a pair of opposites that the shared word 'art' only apparently overbridges." (Campbell 334)

The lyrical bridge of the O'Keeffe is built with these twin forces that invites reflection and touches upon something original. To understand this art is to take flight into billowing clouds and also to take cover in the corner of a warm daydream.

CREATIVE WRITING PROJECT

The above essay is a poetic and philosophical discourse about the author's encounter with a Georgia O'Keeffe painting. O'Keeffe, who lived from 1887 to 1986, was one of a number of very original American painters who began their careers in the first decade or two of the twentieth century and who all created original bodies of work throughout the later decades of the last century. Artists such as John Marin, Arthur Dove, and Marsden Hartley are a few of these American originals. Select one such American painter whom O'Keeffe was associated with and apply a similar technique of creative philosophical writing observed in this chapter to produce a 750 word essay that reveals your experience with and thoughts about an individual painting by one of these artists. Be descriptive about the work but, also allow yourself to relate the work to your own experiences and to your own philosophical musings.

Chapter 27
Kathe Kollwitz: The World at War

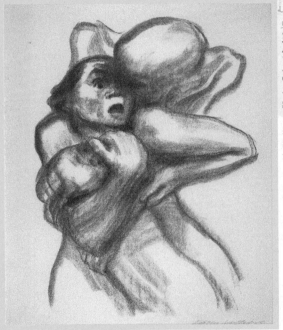

Death Seizing a Mother, 1934 (lithograph), Kollwitz, Kathe Schmidt (1867–1945) / Dallas Museum of Art, Texas, USA / purchased with grant from The Assemblage / Bridgeman Images. © 2014 Artists Rights Society (ARS), New York/VG Bild-Kunst, Bonn

Death Seizes a Woman, 1934 Lithograph (MoMA)

Kathe Kollwitz was born Kathe Schmidt in 1867 in Germany and lived through both the first and second World Wars. Her parents were supportive of her artistic tendencies and she was encouraged by them to study art in Munich. Best known as a printmaker and sculptor, she lived in Berlin with her physician husband, Karl Kollwitz experiencing and recording the lives of the poor who were tended to by her husband.

A skilled draughtswoman, Kollwitz was highly adept at capturing the pain and suffering of those most affected by the poverty and horrors that were suffered by those individuals she encountered in Germany during the first half of the twentieth century. The work, primarily woodblock prints, lithographs, drawings, and sculptures, have an air of pain and anguish that serve as a protest to the tragedies she witnessed firsthand. Many of her works focus on mothers and children and the loss of life. Her own son was killed in battle during the First World War and her grandson was killed during the Second World War.

The lithograph, Death Seizes a Woman, was part of a series of lithographic prints Kollwitz created in the last decade of her life. In all, the series devoted to Death includes eight lithographs. Her emotionally charged images demonstrate not only Kollwitz's skills as an expressionist but her deeply felt and sincere empathy for those who were tormented by the acts of brutality that circled throughout Europe during both World Wars.

Lithography has been used as a means to create multiple works of art since 1798. The technique used by Kathe Kollwitz and other artists since the mid-nineteenth century and still in use today is known as Stone Lithography. The fundamental aspects of this printmaking practice is the use of a grease based tool, such as a lithograph crayon or the use of a brush with a more fluid grease, to draw the image directly onto a prepared piece of Bavarian limestone. Once the drawing is completed, the stone is moistened with water which, of course, is repelled by the greasy surfaces. Printer's ink is rolled onto the stone where-in only the greasy surfaces of the stone attract the ink. The final step is the laying on of a piece of paper to the top of the stone and the running of the stone through a press to impress the ink from the stone onto the paper.

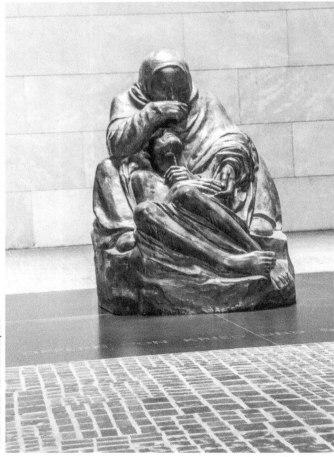

© Kiev.Victor/ Shutterstock, Inc.

Pieta, 1937-38, located in the Neue Wache in Berlin, Germany (A memorial to the victims of war)

When the National Socialist Party (NAZI) took power in 1933 in Germany, Kollwitz began to be pressured and harassed by the Nazis then in authority. In 1919, she was appointed the first woman professor at the Prussian Academy of Art and in 1933, the Nazis forced her to resign her position and she was prohibited from displaying any of her artwork. She, however, continued to work on her art, completing the series of lithographs on Death and continuing to create sculpture.

Kollwitz work in printmaking and sculpture is usually included in art history books as part of German Expressionism. During and after the First World War, German artists sought to depict the emotional turmoil of the time, as well as the corrupt nature of those in power. Sometimes referred to as Neue Sachlichkeit in German, the term refers to the poignantly observant realism of the focus of these artists.

Expressionism, a term used in art history, is applied to works of art that portray objective reality through the exaggerations, distortions, and imaginative intuition of the individual artist. The term may apply to artists as disparate as Goya, van Gogh, and Kollwitz. In each case, the artist's demonstrative intensity and the emotionally charged nature of the subject matter are at the forefront of the imagery.

In 1940, Karl Kollwitz died and in 1943 Kathe Kollwitz's home was destroyed during the allied bombing of Berlin. In 1944 she moved to Moritzburg in the Saxony region of Germany and on April 22, 1945 she died there. Her life is a testament to the pursuit of social justice through art and the desire to leave a record of the pain and suffering she witnessed around her.

RESEARCH PROJECT

Kollwitz suffered the pains of personal loss as well as the sorrows of those whom she knew and encountered. Her work as a pacifist and chronicler of the death and anguish in Germany through both World Wars is a lasting record of the tragic results of those wars as well as a representation of human suffering in general. Research other artists whose work may be characterized as part of German Expressionism. Write a 750 word essay discussing their art and what social tribulations are depicted and commented upon through the art.

Chapter 28

Lavender Mist, 1950 by Jackson Pollock: Modern Art

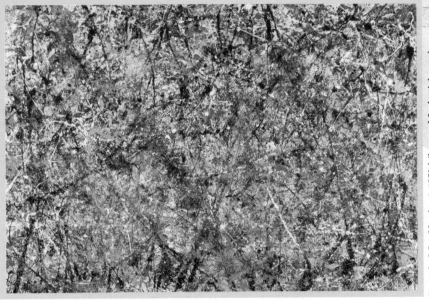

Lavender Mist: Number 1, 1950 (oil, enamel & aluminium paint on canvas), Pollock, Jackson (1912-56) / National Gallery of Art, Washington DC, USA / Bridgeman Images. © 2014 The Pollock-Krasner Foundation/ Artists Rights Society (ARS), New York

Owned by the National Gallery of Art in Washington, DC and formally titled, Number One, 1950, Lavender Mist is an expansive painting by one of the most famous of the twentieth century's artists, Jackson Pollock. Born in Cody, Wyoming in 1912, he was moved to San Diego, California shortly after his birth. At the age of one, he moved to Phoenix, Arizona and in 1917 to Chico, California where he lived until 1922 when the family moved to Janesville, California. In 1923, he moved back to Phoenix and in 1924 back to Chico, and in 1925 to Riverside, California. After this dizzying back and forth between Arizona and California, Pollock ended up in Los Angeles at the Manual

Arts High School until he was expelled in either 1928 or 1929. In 1930 he was reemitted to Manual Arts and in that same year he left California for New York City. Pollock found himself in New York at a time of tremendous change in the world of art and in a place that was rapidly becoming the center of world attention for innovation in the visual arts.

A passionate, troubled, and volatile personality led Pollock to invent an aesthetic vocabulary unique in American and world art history. While the history of art is full of stories of discovery and of the role of the art critic in the publicizing of an individual artist, the relationship between the capricious Pollock and the equally fiery art critic Clement Greenberg is one that is notable for the give and take between the two temperamental luminaries.

Pollock's method of drip painting and his dance around and above the canvas, which was laid flat on the floor, broke away from the tradition of easel painting and from seeing the canvas as a fixed space within which to design a composition. Pollock's seminal works break away from painting as a window unto another world and provide the viewer with a sprawling swatch of space that, metaphorically, extends infinitely beyond the boundaries of the sizeable canvas on which he flung his paint.

Pollock and his wife, the artist and equally revolutionary painter Lee Krasner, left the hustle and bustle of Greenwich Village in New York City's urban hub of artistic activity for the bucolic beauty of the then sparsely populated East Hampton on the further end of Long Island. It was here, in a converted barn to studio, that Pollock created some of his iconic masterpieces of Abstract Expressionism. Once completed, he and his advocate, the critic Clement Greenberg, decided on the title of his masterfully executed painting Lavender Mist.

Jackson Pollock left his family and home in California at the age of eighteen to pursue a career as a painter in New York City. He used the city's great museums as his school in order to study the art of the past and he took lessons from the great American realist painter Thomas Hart Benton whose swirling compositions left a lasting impression on the self-taught Pollock.

Pollock's genius was his ability to fuse his deeply felt emotions with a sense of the history of art to create a totally new and exhilarating form of painting. The entire body of the artist is thrown into the action of the painting and the spontaneous and intuitive decisions of the artist in the act of painting is of primary importance. Thusly, Pollock bonded the content of the painting with the form of the painting creating one continuous stream of bold imagery.

In August, 1956, Pollock's reckless life style caught up with him and while drunk, he crashed his car into a tree on his way home on Long Island and killed himself and one of the two female occupants of the car as well. He left a prodigious legacy of innovative art that has helped shape the notion of what modern art is.

Sometimes known as the New York School, the abstract expressionist painters that congregated on 10th Street and its environs in Greenwich Village in lower Manhattan in New York City represented a wide range of stylistic approaches to unfolding their own personal vision of a world only visible on their canvases. Approximately the time period just at the end of the Second World War, 1945 and up to the early 1960's may be considered the high point of activity of these experimental artists. Included in this group are Pollock and his wife Lee Krasner, Willem de Kooning and his wife Elaine de Kooning, Mark Rothko, Barnett Newman, Franz Kline, and many others.

STUDIO PROJECT ...

Taking as your inspiration the drip paintings of Jackson Pollock, create an action painting that best represents your emotional state at the time you started to work on the painting. On a large sheet of paper set on the floor, use tempera or any other water based painting medium to create an all-over sweep of lines and colors that produces an effect of being as if you had cut out a swatch from an never ending expanse of painting. Spend time looking at on-line reproductions of Pollock's paintings to get inspiration for your own abstract expressionist creation.

Chapter 29

Andy Warhol's Campbell's Soup Can: Pop Art

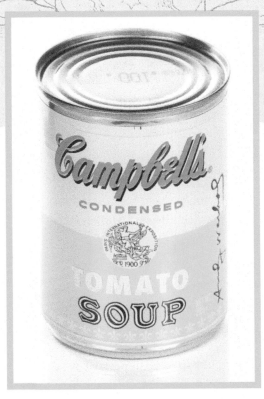

© Thinglass/ Shutterstock, Inc.

Andy Warhol was born as Andy Warhola in 1928 in Pittsburgh, Pennsylvania. He atttended Carnegie Institute of Technology before leaving Pittsburgh for New York City in 1949. His background in advertising and commercial art informed his later work as one of the masters of Pop Art. Using popular cultural imagery and the graphic images from commercial products, such as Campbell's Soup cans,

Warhol defined the cool movement in art that dominated the 1960's and early 1970's artworld. His silk-screen prints of everything from Brillo Soap Pad boxes to images of Marilyn Monroe have become synonomous with the name Warhol.

Richard Hamilton, Just What Is It that Makes Today's Homes So Different, So Appealing?, 1956 Collage

British art critic Lawrence Alloway coined the term Pop Art when writing about English artist Richard Hamilton's collage that included an image of a Tootsie Pop. The term has since come to represent those artists using either everyday objects and familiar imagery in their art, such as Robert Rauschenberg and Jasper Johns, as well as those artists using commercial graphic art techniques to produce cool, slick imagery that plays on and appropriates the visual representation of everything from celebrities to soup cans, such as the work of Andy Warhol.

One of the significant aspects underlying Warhol's artwork is his breaking down the barrier between what was considered high brow subject matter, such as portraiture, landscape painting, or even the intellectual and personally emotional work of the abstract expressionists and the early Modernists, and that of so called low brow subject matter: the everyday images and products of middle-class America. Warhol called his studio in New York City The Factory and much like industrial factories it was a place for him to direct his numerous assistants in the creation of his art. He even emphasized the absence of his own hand in the production of his work as a very up-to-date and modern reality of art. He was a champion of the mass produced and the mundane. He not only produced his world reknowned silkscreens at The Factory but, he also made films, and he supported avant garde music such as that created by the Velvet Underground.

Warhol died on February 22, 1987 in New York City. His creative manipulation of popular culture in America has had a lasting impact on the history of art.

STUDIO PROJECT

In the early 1960's Andy Warhol appropriated everyday imagery and product design from the shelves and pantries of American markets and home kitchens. In The Factoy, his studio in New York City, he directed his assistants to construct virtual facsimiles of actual consumer items, such as Brillo Soap Pad boxes. These Warhol Factory made items were indistinguishable from those found in grocery stores across the country. It was this ordinariness, this mundaness of the everyday consumer world that Warhol wanted to capture in his replicas. Your studio project is to find a contemporary consumer product to duplicate in your own Factory.

Serigraphy, more commonly known as silk-screening, is a printing process based on the same principle as stenciling. A mesh screen is stretched around a wooden frame. A cut paper stencil or masking material is affixed to the surface of the screen and the paper is placed beneath the screen. A squeegee like tool is used to squeeze ink through the screen onto the paper below. Multiple screens are used in progression in multiple color prints. Andy Warhol used photographic images that were stenciled onto large silkscreens as the format for some of his most famous images.

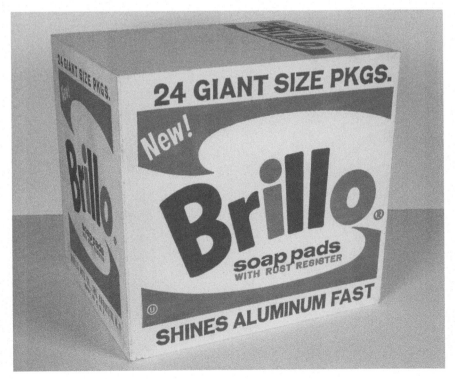

Brillo Box, 1964 (synthetic polymer paint & screenprint ink on wood), Warhol, Andy (1928-87) / Davis Museum and Cultural Center, Wellesley College, MA, USA / Museum purchase and partial gift of The Andy Warhol Foundation for the Visual Arts, Inc. / Bridgeman Images. © 2014 The Andy Warhol Foundation for the Visual Arts, Inc./Artists Rights Society (ARS), New York

Chapter 30

Kara Walker: The Art of Today

Gone: An Historical Romance of a Civil War as It Occurred Between the Dusky Thighs of One Young Negress and Her Heart, 1994 (MoMA)

Born in Stockton, California in 1969, Kara Walker has quickly become one of the most sought after and significant artists of the twenty first century. Her wall filling silhouettes constructed out of black cut paper provide an intelligent and heartfelt commentary on the history of racial and gender conflict and strain in America. The use of the silhouette as a dominant technique in her work harkens back to a time in American colonial history and into the early years of the formation of the nation when such cut-paper outlines were popular in capturing the contoured likeness of a person. Connecting this folk art form with Walker's

keen perspective on issues of race, oppression, slavery, and woman's rights has created for viewers a growing unease due to the presence of these beautiful forms that contrast so sharply with the agitated content of the tableaux.

In her early teens, Walker moved with her family to Stone Mountain, Georgia where her father, artist Larry Walker, began work at Georgia State University. Kara Walker focused her academic career on painting and printmaking and received her MFA from the Rhode Island School of Design in 1994. She rapidly rose among the ranks of important young artists and through her insightful and highly astute installations in major museums and galleries, Walker was the youngest person to be awarded the John D. and Catherine T. MacArthur Foundation prize, known as the Genius Grant. Kara Walker is currently a professor of visual arts at Columbia University in New York City.

A Tableaux is a grouping of figures to represent a story or a scene from history. Usually a tableaux is a strikingly rich illustration of a familiar scene or famous moment in history. Kara Walker's Tableaux are thoughtful re-interpretations of and commentaries about stereotypes about African-Americans and women.

Kara Walker (b. 1969) *African/American*, 1998 (linocut)

© Kara Walker
African, American, 1998
Linoleum cut
46.25 x 60.5 inches/117.5 x 153.7 cm (sheet)
Edition of 40
Publisher/Printer: Landfall Press, Inc., Chicago / Saint Louis Art Museum, Missouri, USA/Museum Minority Artists Purchase Fund/Bridgeman Images.

Kara Walker, like other artists in the post-modern era, has thoughtfully reflected on issues of identity and how one defines themselves and how groups of people are defined by others. In particular, Walker reflects on how historical images and literary representations of African-Americans and women have distorted and misrepresented the realities and struggles of these groups. Her work is a complex approach to and pensive observation on difficult questions surrounding the history of racial tension in America.

Kara Walker continues to make works of art that surprise, shock, and ultimately question long held assumptions about how we represent ourselves and how others represent us. Her "A Subtlety, or the Marvelous Sugar Baby" was created in April 2014 in the soon to be demolished Domino Sugar Factory in the Williamsburg district of Brooklyn, New York. Using polystyrene blocks which were then covered with tons of sugar, Walker created a sphinxlike image which has since been dismantled and destroyed. A dozen plastic casts of the ephemeral sculpture, coated in sugar, were produced.

The 75 foot long sculpture makes a comment on the image of the slave and reflects on the role of slavery in the history of the sugar industry. Walker has created a powerful visual statement that has yet again, as she has done in her work to date, brought forward important concerns about the hidden truths behind contemporary mores.

Post Modern or Postmodernism is a term that refers to the cultural shift away from the Modernist paradigm of the universality of thought, art, and culture as being a concrete definable world view to a perspective that contemplates and celebrates diversity, individuality, and the authenticity of an individual's perspective and expression of themselves. In a postmodern world, the pursuit of looking for one unifying concept and expression for all humanity is replaced with the reality of the vibrant and colorful richness that is the diversity of the human condition.

© SHANNON STAPLETON/Reuters/Corbis

STUDIO PROJECT ..

Kara Walker uses a type of antique art, the silhouette or a contour paper cut out of a subject resulting in a single block of colored paper representing the outline of the figure or animal or scene, in producing her tableaux. Using black paper, create a silhouette or cut paper work of art that represents your reflection on your identity. In what ways do you feel that your personal identity and the group or groups that you identify with have been or are portrayed by others in popular culture today and in the past? Affix your completed silhouette onto a white piece of paper and title it in a way that allows the viewer to get a better understanding of the intent of your silhouette.

Conclusions

This text has been intended to serve as a taster of sorts of the breadth of human creativity through the examination of thirty products of the human imagination. After reviewing these thirty works of art you have acquired some knowledge about the materials used by people across time and place and the methods they employed to create magnificent objects out of those materials. Whether it be mosaic tiles as seen in Chapter 6 or lithographic processes as revealed in Chapter 26, the use of natural and man-made materials in both monumental and intimate scale works of art is ubiquitous in human history.

Of course, it is the people themselves, the unknown laborers and the individual people who have become synonymous with the word artist that have made it possible for us to revel in the diversity of humanity's artistic creations. From the slave laborers who built the Great Pyramid of Giza to the brilliant innovations of the genius artist Pablo Picasso, the art of our world represents both universal principles and world views, as well as the singular dreams and pursuits of talented and gifted individuals.

As witnessed through the thirty exemplars listed here-in, the themes and traditions of cultures from across the globe are limitless. From religious ico-

nography to comments on social ills to celebrations of the natural environment to documentation of important political milestones, the art and artists represented in this text have explored the motifs and ideas that have and continue to matter in our world.

Hopefully, you the reader have been inspired to explore more of the visual arts and to discover not just the facts about the history of art and culture but, to find something relevant about the study of the visual arts to your own life, to translate the meanings found within art into significant action and self-revelation.

FINAL PROJECT

The final project in this textbook is for you to create an alternate list of thirty works of art that every student should know and understand. Of course, there are numerous alternative listings for an inventory of thirty works of art that we should all know. In your list, try to do what I have done: make a list that spans human history, make a list that tries to capture a global perspective, make a list that has some of the exemplary art or architecture of a time and place, and a list that has personal significance for you, art that you are drawn to and that opens up a world of exploration and wonder for you and others.

Appreciations

I am appreciative of the work of the editors at Kendall Hunt Publishing Company, in particular the work of Brenda Rolwes, Lauren Milam, and Tiffany Siefker. I am also appreciative of my colleagues in the School of Art and Design at the University of Northern Colorado, in particular the support and encouragement of the former Director of the School, Dr. Dennis Morimoto and the current Director, Andrew Licardo. I am appreciative of the editorial advice of Dr. L. S. Wolff and the owners of cabins in Leadville, Colorado and Taos, New Mexico who afforded me the quietude necessary to write this book. As always I am appreciative of my five children for their enthusiasm of my work on this project; thank you Aaron, David, Hannah, Zoe, and Summer.

Resources

Chapter 1: Lascaux: The Beginnings

Web Sites:

http://www.lascaux.culture.fr/?lng=en
http://www.bradshawfoundation.com/clottes/index.php

Books:

Cave Art by Dr. Jean Clottes, Phaidon Press 2010
Palaeolithic Rock Art in Western Europe by Andrew J. Lawson, Oxford
 University Press 2012

Chapter 2: The Great Pyramids of Giza: The Monumental

Web Sites:

http://www.sca-egypt.org/eng/SITE_GIZA_MP.htm

http://www.discoveringegypt.com/pyramids-temples-of-egypt/pyramids-of-giza/
http://www.nationalgeographic.com/pyramids/khufu.html
http://www.pbs.org/wgbh/nova/pyramid/explore/gizahistory.html
http://www.gizapyramid.com/overview.htm

Books:
The Great Pyramids of Giza by Alain D'Hooghe, Vilo Publishing, 2000
Great Pyramid of Giza : Measuring Length, Area, Volume, and Angles by Janey Levy, Rosen Publishing
 Group, 2009
Building the Great Pyramid by Kevin Jackson, Jonathan Stamp, Firefly Books, 2003

Chapter 3: Discobolus by Myron: The Classical Greek World

Web Sites:
http://www.britishmuseum.org/explore/highlights/highlight_objects/gr/d/discus-thrower_discobolus.aspx
http://www.youtube.com/watch?v=OhJKDqZgNXg

Books:
The Discobolus by Ian Jenkins, British Museum Press, 2012
Archaic and Classical Greek Art (Oxford History of Art) by Robin Osborne, Oxford University Press, 1998

Chapter 4: Pompeii: The Roman Empire

Web Sites:
http://www.eyewitnesstohistory.com/pompeii.htm
http://www.smithsonianmag.com/history/resurrecting-pompeii-109163501/
http://www.pompeionline.net/pompeii/

Books:
The Complete Pompeii by Joanne Berry, Thomas & Hudson, 2007
Pompeii: The Life of a Roman Town by Mary Beard, Profile Books Ltd, 2009

Chapter 5: The Terra Cotta Warriors: The Great Wall and the Qin Dynasty

Web Sites:
https://www.google.com/earth/
http://science.nationalgeographic.com/science/archaeology/emperor-qin/
http://www.smithsonianmag.com/history/terra-cotta-soldiers-on-the-march-30942673/
http://whc.unesco.org/en/list/441

Books:

China's Terracotta Warriors: The First Emperor's Legacy by Yang Liu, University of Washington Press, 2012

China's First Emperor and His Terracotta Warriors by Frances Wood, St. Martin's Press, 2008

Chapter 6: The Good Shepherd: The Dawn of Christian Art

Web Sites:

http://www.sacred-destinations.com/italy/ravenna-galla-placidia

https://www.khanacademy.org/humanities/art-history/art-history-400-1300-medieval---byzantine-eras/early-christian/v/the-mausoleum-of-galla-placidia--ravenna

http://gohistoric.com/places/318306

http://lauramorelli.com/2014/04/04/ravenna-italy-what-you-should-know-about-its-mosaics/

Books:

The Mausoleum of Galla Placidia in Ravenna by Angiolini Martinelli, Franco Cosimo Panini, 2009

Byzantine Mosaics by Nano Chatzidakis, Ekdotike Athenon, 1994

Chapter 7: The Great Buddha of Kamakura: Buddhist Art

Web Sites:

http://www.sacred-destinations.com/japan/kamakura-great-buddha

http://www.kotoku-in.jp/en/about/about.html

http://muza-chan.net/japan/index.php/blog/spiritual-look-great-buddha-kamakura

Books:

Discovering the Arts of Japan: A Historical Overview by Stephanie Wada, Abbeville Press Publishers, 2010

Chapter 8: Persian Miniatures: The Art of Islam

Web Sites:

http://art.thewalters.org/detail/19840/album-of-persian-miniatures-and-calligraphy-2/

http://exhibitions.slv.vic.gov.au/love-and-devotion/education/activities/persian-miniature-painting-visual-literacy

http://www.hermitagemuseum.org/html_En/04/2007/hm4_2_228.html

Books:

Persian Miniature Painting: And Its Influence on the Art of Turkey and India by Norah M. Titley, British Library, 1983

Islamic Art and Spirituality By Seyyed Hossein Nasr, SUNY Press, 1987

Art of Islam, Language and Meaning by Titus Burckardt, Wisdom Inc., 2009

Chapter 9: The Book of Kells: The Middle Ages

http://www.tcd.ie/Library/bookofkells/ Web Sites:
http://www2.liu.edu/cwis/cwp/library/sc/kells/kells.htm

Books:
The Book of Kells: An Illustrated Introduction to the Manuscript in Trinity College, Dublin by Bernard
 Meehan, Thames and Hudson 1994
The Book of Kells: Its Function and Audience by Carol Farr, British Library, 1997

Chapter 10: Chartres Cathedral: The Gothic World

Web Sites:
http://www.cathedrale-chartres.org/en/,143.html
http://whc.unesco.org/en/list/81
http://www.chartrescathedral.net/

Books:
Universe of Stone by Phillip Ball, Random House, 2008
High Gothic Sculpture at Chartres Cathedral by Anne McGee Morganstern, The Pennsylvania State Uni-
 versity, 2011

Chapter 11: The Lamentation of Christ by Giotto: The Start of the Renaissance

Web Sites:
http://www.giottodibondone.org/
http://www.artmuseums.com/giotto.htm#.U-Oqr3leHIU

Books:
The Cambridge Companion to Giotto edited by Anne Derbes, Mark Sandona, Cambridge University
 Press, 2003
Storytelling in Christian Art from Giotto to Donatello By Jules Lubbock, The British Library, 2006

Chapter 12: Mona Lisa by Leonardo da Vinci: The Genius of the Renaissance

Web Sites:
http://www.leonardoda-vinci.org/
http://www.metmuseum.org/toah/hd/leon/hd_leon.htm
http://www.louvre.fr/en/oeuvre-notices/mona-lisa-%E2%80%93-portrait-lisa-gherardini-wife-frances-
 co-del-giocondo

Books:

Leonardo Da Vinci By John Malam, Heinemann Raintree 2009

Mona Lisa: Inside the Painting by Jean-Pierre Mohen, Michel Menu, Bruno Mottin, Harry N. Abrams, 2006

Chapter 13: The Sistine Chapel by Michelangelo: The Height of the Renaissance

Web Sites:

http://mv.vatican.va/3_EN/pages/CSN/CSN_Main.html

http://www.history.com/news/7-things-you-may-not-know-about-the-sistine-chapel

http://www.wga.hu/tours/sistina/index3.html

Books:

Michelangelo and the Sistine Chapel By Andrew Graham-Dixon, Sky Horse Publishing, 2009

The Sistine Chapel: A New Vision by Heinrich Pfeiffer, Abbeville Press, 2007

Chapter 14: Indian Sculpture: The Hindu World

Web Sites:

http://www.metmuseum.org/toah/hi/hi_rehis.htm

https://www.asia.si.edu/pujaonline/puja/how_sculptures.html

Books:

Principles of Composition In Hindu Sculpture by Alice Boner, Brill Publishers, 1962

Indian and South-East Asian Stone Sculptures from the Avery Brundage Collection by Rene-Yvon Lefe-
 bvre & Terese Tse, Pasadena Art Museum, 1969

Chapter 15: Aztec Sculpture: The New World

Web Sites:

http://www.denverartmuseum.org/collections/pre-columbian-art

http://www.worcesterart.org/Collection/precolumbian.html

Books:

Guide to Pre-Columbian Art by Jean Paul Barbier, Museu Barbier-Mueller Art Precolombí, 1998

Pre-Columbian Art by Esther Pasztory, Cambridge University Press, 1998

Chapter 16: The Great Wave of Kanagawa by Hokusai

Web Sites:

http://roningallery.com/

http://ukiyo-e.org/

Books:

Ukiyo-E by Dora Amsden and Woldermar von Seidlitz, Parkerstone Press, 2014

Hokusai and His Age: Ukiyo-e Painting, Printmaking and Book Illustration in Late Edo Japan by John T. Carpenter, Hotei, 2005

Chapter 17: Dogon Art

Web Sites:

http://www.metmuseum.org/collection/the-collection-online/search/310765

http://www.zyama.com/dogon/pics..htm

http://www.africanart.org/future/40/dogon_now_masks_in_motion

Books:

Facing the Mask by Frank Herreman, Museum for African Art, New York, 2002.

Material Differences: Art and Identity in Africa edited by Frank Herreman, Museum for African Art, New York, and Snoeck-Ducaju & Zoon, Gent. 2003

Chapter 18: El Greco: The Age of the Inquisition

Web Sites:

https://www.nga.gov/collection/gallery/gg29/gg29-main1.html

http://www.metmuseum.org/toah/hd/grec/hd_grec.htm

http://www.spainisculture.com/en/museos/toledo/casa-museo_de_el_greco.html

Books:

El Greco by Michael Scholz-Hänsel, Taschen, 2004

El Greco by Santiago Alcolea, Distributed Art Pub Incorporated, 2007

Chapter 19: Self Portrait by Rembrandt: The Dawn of the Modern Era

Web Sites:

http://www.rembrandtpainting.net/

http://www.metmuseum.org/toah/hd/rmbt/hd_rmbt.htm

Books:

Dutch Masters Frans Hals, Johannes Vermeer, and Rembrandt Van Rijn by Cynthia Swain, Benchmark Education, 2011

Rembrandt's Eyes by Simon Schama, Random House of Canada, Limited, 2001

Chapter 20: Liberty Leading the People: The Age of Enlightenment

Web Sites:

http://smarthistory.khanacademy.org/romanticism-in-france.html

http://www.louvre.fr/en/oeuvre-notices/july-28-liberty-leading-people

Books:

David to Delacroix: The Rise of Romantic Mythology by Dorothy Johnson, The University of North Carolina Press, 2011

Delacroix edited by Gilles Néret, Taschen, 2004

Chapter 21: The Oath of the Horatii by Jacques-Louis David, 1784: Neo-Classicism

Web Sites:

http://www.jacqueslouisdavid.org/

http://www.metmuseum.org/toah/hd/jldv/hd_jldv.htm

Books:

Jacques-Louis David: Empire to Exile by Philippe Bordes, The J. Paul Getty Museum, 2005

David and Neo-classicism by Sophie Monneret, Terrail, 1999

Chapter 22: The 3rd of May 1808, painted by Goya in 1814: Romanticism

Web Sites:

http://smarthistory.khanacademy.org/goyas-third-of-may-1808.html

https://www.mtholyoke.edu/~nigro20e/classweb/Third%20of%20May.html

http://www.wga.hu/frames-e.html?/html/g/goya/7/714goya.html

Books:

Goya by Fred Licht, Abbeville Press, 2001

Francisco Goya, 1746-1828 by Rose-Marie Hagen, Francisco de Goya, Rainer Hagen, Taschen, 2003

Chapter 23: Water Lilies by Claude Monet: Impressionism

Web Sites:

http://www.moma.org/collection/object.php?object_id=80220

http://www.metmuseum.org/collection/the-collection-online/search/438008

http://fondation-monet.com/en/

Books:

Claude Monet: Water Lilies by Ann Temkin, Museum of Modern Art, 2009

Monet: In the Time of the Water Lilies : the Musée Marmottan Monet Collections by Marianne Delafond, Caroline Genet-Bondeville, Scala, 2002

Chapter 24: Self Portrait by Vincent Van Gogh: Post Impressionism

Web Sites:

http://www.newyorker.com/magazine/2010/01/04/van-goghs-ear?currentPage=all

http://www.metmuseum.org/toah/hd/gogh/hd_gogh.htm

http://www.vangoghmuseum.nl/vgm/index.jsp?page=101&lang=en

Books:

Van Gogh: The Life by Steven W. Naifeh, Gregory White Smith, Woodward/White, Inc., 2011

Vincent Van Gogh: A Self-portrait in Art and Letters by H. Anna Suh, Black Dog & Leventhal Publishers, 2006

Chapter 25: Les Demoiselles D'Avignon by Pablo Picasso: Cubism

Web Sites:

http://www.pablopicasso.org/

http://www.moma.org/collection/object.php?object_id=79766

http://www.bcn.cat/museupicasso/en/

http://www.picasso.fr/us/picasso_page_index.php

Books:

Picasso: Style and Meaning, by Elizabeth Cowling, Phaidon Press, 2004

Pablo Picasso by Victoria Charles, Confidential Concepts, 2011

A Picasso Portfolio: Prints from the Museum of Modern Art by Deborah Wye, Museum of Modern Art, 2010

Chapter 26: Georgia O'Keeffe: An American Original

Web Sites:

http://www.okeeffemuseum.org/

http://www.metmuseum.org/toah/hd/geok/hd_geok.htm

Books:

Portrait of an Artist by Laurie Lisle, Washington Square Press, 1986

Georgia O'Keeffe by Gerry Souter, Parkstone International, 2011

Chapter 27: Kathe Kollwitz: The World at War

Web Sites:

http://www.kollwitz.de/en/lebenslauf.aspx
http://www.moma.org/collection/artist.php?artist_id=3201

Books:

The Diary and Letters of Kaethe Kollwitz by Käthe Kollwitz, Northwestern University Press, 1988
Prints and Drawings of Käthe Kollwitz by Käthe Kollwitz, Courier Dover Publications, 2012

Chapter 28: Lavender Mist, 1950 by Jackson Pollock: Modern Art

Web Sites:

http://www.jackson-pollock.org/
http://www.nga.gov/feature/pollock/
http://www.moma.org/collection/artist.php?artist_id=4675

Books:

Jackson Pollock by Ellen G. Landau, Harry N. Abrams, 2010
Jackson Pollock by Evelyn Toynton, Yale University Press, 2012

Chapter 29: Andy Warhol's Campbell Soup Can: Pop Art

Web Sites:

http://www.warhol.org/
http://www.warholfoundation.org/
http://www.pbs.org/wnet/americanmasters/episodes/andy-warhol/a-documentary-film/44/

Books:

The Philosophy of Andy Warhol: From A to B and Back Again by Andy Warhol, Houghton Mifflin Harcourt, 1977
Andy Warhol by Arthur C. Danto, Yale University Press, 2009

Chapter 30: Kara Walker: The Art of Today

Web Sites:

http://learn.walkerart.org/karawalker
http://www.pbs.org/art21/artists/kara-walker
http://www.nytimes.com/2014/04/27/arts/design/kara-walker-creates-a-confection-at-the-domino-refinery.html?_r=0

Books:

Kara Walker: My Complement, My Enemy, My Oppressor, My Love by Philippe Vergne, Sander L. Gilman, Walker Art Center, Whitney Museum of American Art, Walker Art Center, 2007

Seeing the Unspeakable: The Art of Kara Walker by Gwendolyn DuBois Shaw, Duke University Press, 2004

About the Author

Currently Professor of Art and formerly Dean of the College of Performing and Visual Arts at the University of Northern Colorado, Dr. Svedlow was previously the Dean of the College of Visual and Performing Arts at Winthrop University, President of the New Hampshire Institute of Art, and Assistant Director of the Museum of the City of New York. Dr. Svedlow received his Ph.D. from the Pennsylvania State University and has taught art appreciation, Asian art history, arts administration and museum leadership, aesthetics, art education, and studio art at Northern Colorado, Winthrop University, Penn State, Bank Street College of Education, Parsons School of Design, University of Massachusetts-Dartmouth and Lowell, University of Kansas, New York University, University of Southern Mississippi, the New Hampshire Institute of Art, and the University of New Hampshire. Dr. Svedlow was a 1991 International Council of Museums/USIA exchange partner in

Australia, he was a 1994 Research Fellow with the Smithsonian Institution, and in 1998 he participated in a cultural exchange between business and civic leaders in Niigata, Japan. In 1996, Dr. Svedlow was presented the Distinguished Service to the Profession of Art Education Award by the New Hampshire Art Educators' Association and in 1998 Dr. Svedlow completed the MLE Program in the Harvard Graduate School of Education's Institute for Higher Education and was a member of the American Association of State Colleges and Universities' Millennium Leadership Initiative 2002. He has directed and administered museum and education programs for the Smithsonian's National Museum of Design, the Museum of the City of New York, and the Mulvane Art Museum at Washburn University. He was a 2007 Fulbright Scholar for the Japan-US International Education program and was a 2010 Fulbright Scholar to Ukraine.

Dr. Svedlow has published on Japanese art, phenomenology, aesthetics, art history, art education, museum education, and arts administration. A painter and printmaker, Dr. Svedlow's artworks have been exhibited in galleries and museums across the country and internationally. He is currently a studio artist in residence at Artworks Loveland, an artists' community in Loveland, Colorado.

Dr. Svedlow is a Senior Fellow of the American Leadership Forum and is a graduate of the 1997 Leadership New Hampshire program and a 1994 graduate of Leadership Manchester, NH and was appointed by the Governor of New Hampshire as Chairman of the Commission of the Christa McAuliffe Planetarium. He participated in the 2007 Aspen Institute Executive Seminar and was an Aspen Institute Environment Forum Scholar in 2009. Dr. Svedlow was one of the founding college presidents of the New Hampshire Campus Compact and he is an active supporter of service learning in higher education. In 1997 he was awarded the Good Samaritan of the Year Award from the New Hampshire Pastoral Counseling Services and was selected, in 1998, by Change Magazine as one of the country's Top Forty Young Leaders in Higher Education. He has served as a grant panelist for the National Endowment for the Arts, the Fulbright Program, and numerous regional and state granting agencies.

Index

A

Abstract Expressionism, 114
Acropolis (Athens, Greece), 12, 14
Africa, Dogon art of, 71–74
African/American (Walker), 122
Alexander the Great, 35, 36
Ali, Qasim, 38
allegory, 84
Alloway, Lawrence, 118
Altamira Cave (Spain), 4
ancestor worship, 73
Ancestral Female (sculpture), 71, 72
anthropomorphism, 60
AR Denarius (Roman coin), 16
Arena Chapel (Padua, Italy), 47–49
artists, talent of, 125–126. *see also individual names of artists*
Aztec sculpture, 63–66

B

Bachelard, Gaston, 107
Bastille Saint-Antoine (engraving), 87
Bedroom, The (Van Gogh), 98
Behzad, 37, 38
Benton, Thomas Hart, 114
Berlin, Isaiah, 91
Bertoldo di Giovanni, 56
Bison (Altamira Cave, Spain), 4
Blue Mosque (Tabriz, Iran), 36
Blue Period (Picasso), 102
Book of Kells, 39–42
Borchardt, Ludwig, 7
Brahma, 61
Braque, Georges, 102
Brillo Box (Warhol), 119
British Museum, 11, 12
Buddha at Polonnaruwa (Sri Lanka), 32
Buddhist art, Great Buddha of Kamakura, 29–33
Burial of Count Orgaz (El Greco), 76
Byzantine art, 23–27

C

Campbell's Soup Can (Warhol), 117–119
Caprichos, Los (Goya), 90, 92
Cardinal Fernando Niño de Guevara (El Greco), 76
Carter, Howard, 7
Caryatid (Acropolis, Athens, Greece), 14
Catholic Church. *see* Christianity
cave art, of Lascaux, 1–4
Celtic art, 39–42
chacmool, 63, 65
Charles IV (King of Spain), 89
Charles X (King of France), 83
Chartres Cathedral (Chartres, France), 43–46
Chichen Itza (archeological site), 8, 64
Christ Enthroned (Book of Kells), 42
Christianity
 Book of Kells, 39–42
 Chartres Cathedral, 43–46
 Christ in the Garden of Gethesmane (El Greco), 77
 Church of Santa Croce (Florence, Italy), 48
 The Lamentation of Christ (Giotto), 47–49
 The Last Supper (Leonardo da Vinci), 52
 Mausoleum of Galla Placidia (Ravenna, Italy), 23–27
 Sistine Chapel (Michelangelo), 55–58
 Spanish Inquisition and El Greco, 75–78
Cimabue, 49
Classical Greek architecture, defined, 12, 13
Cliff of Bandiagara (Dogon art), 72
Coffee Grinder, The (Van Gogh), 98
coins, of Roman Empire, 16
Cole, Thomas, 84
Coliseum (Rome, Italy), 9
Columban Monks, 41
Constantius III (Emperor of Rome), 25
contour paper, 121–123
Corinthian style, 13
Corneille, Pierre, 86
Cubism, 101–103

D

dancer with mask (Dogon art), 73
David, Jacques-Louis, 85–88
David (Michelangelo), 56
Death of Socrates, The (David), 88, 110
Death Seizes a Woman (Kollwitz), 109
De Bry, Theodor, 65
Dejeuner Sur L'herbe (Manet), 94, 102
Delacroix, Eugene, 83–84
Delian League, 12
Demoiselles d'Avignon, Les (Picasso), 101–103
Din, Kamal ud-, 35
Discobolus (Myron), 11–14
Dogon Ancestral Mask (sculpture), 73
Dogon art, 71–74
Domenico Ghirlandaio, 55
Domino Sugar Factory (Brooklyn, New York), 123
Donato Bramante, 56
Doric style, 12, 13
Dow, Arthur, 106
Dr. Gachet (Van Gogh), 99
Drunkenness of Noah, 55

E

Edo Period (Japan), 67
Eglise de la Madeleine (Madeleine Church), 87
El Greco (Domenikos Theotocopoulos), 75–78
Enlightenment, 83–84
etching, 81
Euclid, 12
Expressionism, 111

F

Factory, The, 118, 119
Ferdinand VII (King of Spain), 91
Figure Prints (Japan), 67
flying buttresses (Chartres Cathedral, France), 44
Four Noble Truths, 31
French Revolution, 86–88
frescoes, 48
Fry, Roger, 99

G

Galla Placidia, 23–27
Ganesha (Indian deity), 60, 61
Gauguin, Paul, 98
Genius Grant (John D. and Catherine T.
 MacArthur Foundation), 122
German Expressionism, 111
Gioconda, Lady, 51–53
Giotto di Bondone, 47–49
Giverny (Normandy, France), 96
Giza (Egypt), 5–10
golden ratio, 12
Gone (Walker), 121
Good Shepherd (Mausoleum of Galla Placidia), 26
Google Earth, 22
Gospel of St. Matthew (Book of Kells), 40
Gothic architecture, 43–46
Goths, 44
Goya (statue), 90
Goya y Lucientes, Francisco de, 89–92
Great Buddha of Kamakura, 29–33
Great Pyramid of Giza (Egypt), 5–10

Great Wall of China, 20–22
Great Wave of Kanagawa, The (Hokusai), 67–70
Greenberg, Clement, 114
Guernica (Picasso), 103

H

Hamilton, Richard, 118
Haystacks, Snow Effects (Monet), 95
Hinduism, Indian sculpture and, 59–62
Hokusai, Katsushika, 67–70
Horace (Corneille), 86
Huitzilopochtli (Aztec deity), 65
Hussain Bayeqra (Sultan), 37

I

iconography, 49
Ieyasu, Tokugawa, 68
illuminated manuscripts, 41
Impression: Sunrise (Monet), 93, 94
Impressionism, 93–96
India, sculpture of, 59–62
Inquisition, 76
Ionic style, 13
Islamic art, Persian Miniatures, 35–38

J

Japanese art, The Great Wave of Kanagawa
 (Hokusai), 67–70
John D. and Catherine T. MacArthur Foundation,
 122
Julius II (Pope), 57
Just What Is It that Makes Today's Homes So
 Different, So Appealing? (Hamilton), 118

K

Kannon, Bodhisattva of Compassion, 31
Khamse (Nizami), 38

Khufu (Pharaoh of Egypt), 5–10
Kobuki, 69
Kollwitz, Karl, 109, 111
Kollwitz, Kathe, 109–111
Krasner, Lee, 114
Krishna (Hindu deity), 61
Kuniyoshi Utagawa (woodblock print), 69

L

Lakshmi (Hindu deity), 61
Lamentation of Christ, The (Giotto), 47–49
Landscape Prints (Japan), 67
Lascaux (Dordogne, France), 1–4
Lastman, Pieter, 79
Last Supper, The (Leonardo da Vinci), 52
Late Republican period, 17
Lavender Mist (Pollock), 113–115
Leonardo da Vinci, 51–53
Leroy, Louis, 94
Levy, Titus, 86
lithography, 109–111
Louis XVI (King, France), 86

M

Madame Recamier (David), 86
Madeleine Church (Paris, France), 87
Madonna of the Meadow (Raphael), 57
Manet, Edouard, 94, 102
Mary Magdalene, 47
Mausoleum at Halicarnassus (Turkey), 24
Mausoleum of Galla Placidia (Ravenna, Italy),
 23–27
Mayan people, sculpture of, 64
meditation mudra, 33
Meiji Restoration, 68
Mengs, Anton, 89
Michelangelo Buonarroti, 55–58
Mirak Naqqash, 38
Mogul Empire (India), 37
Mona Lisa (Leonardo da Vinci), 51–53
Monet, Claude, 93–96
Monks at Kell, 41

Mont Saint Michel (Normandy, France), 45
monumental art, defined, 8
mosaic art, 23–27
Moses (Michelangelo), 57
Mount Rushmore (South Dakota), 9
Mount Vesuvius (Italy), 15–18
mudra, 33
Music, Pink and Blue No. 2 (O'Keeffe), 105–107
Myron of Eleutherae, 11–14

N

Naked Maja (Goya), 91
Namondjok (Nourlangie, Kakadu National Park,
 Australia), 3
Napoleon Bonaparte, 86, 90
Nefertiti (Queen of Egypt), 7
Neo-Classicism, 85–88
Neue Sachlichkeit, 111
New York School, 114
Nietzsche, Friedrich, 107
Night Watch, The (Rembrandt), 80
Nizami, 38
Notre-Dame d'Chartres, 43–46

O

Oath of the Horatii (David), 85–88
O'Keeffe, Georgia, 105–107
Olmec head (sculpture), 64
Olympics, origin of, 12
oratory, 25

P

Pagoda of Six Harmonies (Hangzhou, China), 31
Pagodas, 30
Paleolithic era, defined, 2
Parthenon (Athens, Greece), 12, 13
Persian Miniatures, 35–38
Picasso, Pablo, 101–103
Pieta (Kollwitz), 110

Pliny the Younger, 15
Pollock, Jackson, 113–115
Pompeii (Italy), 15–18
Pop Art, 117–119
Poplars on the Epte (Monet), 96
Post Impressionism, 97–100
Post Modern/Postmodernism, 121–123
proportion, 12
Pythagoras, 12

Q

Qin Dynasty (China), 19–22

R

Rama (Hindu deity), 61
Raphael, 57
Red Bull (Lascaux cave painting, Dordogne,
 France), 3
Reign of Terror (France), 86
Rembrandt van Rijn, 79–82
Renaissance
 defined, 53
 The Lamentation of Christ (Giotto), 47–49
 Mona Lisa (Leonardo da Vinci), 51–53
 Sistine Chapel (Michelangelo), 55–58
Rilke, Rainer Marie, 105
Romanticism, 89–92
Roots of Romanticism, The (Berlin), 91
Rose Period (Picasso), 102
Royal Portal (Chartres Cathedral), 45

S

St. Columba, 41
St. John, 48
St. Peter's Basilica (Vatican City, Rome, Italy), 56
sculpture
 Aztec, 63–66
 Buddhist art, 29–33
 Byzantine, 26

Dogon art, 71–74
Egyptian, 6, 7
Gothic, 43–45
Goya (statue), 90
Greek, 11–14
Indian, 59–62
Renaissance, 56–58
Shogun Ieyasu (statue), 68
Terracotta Warriors (China), 19–20
Second Style, 17
Self-Portrait with Bandaged Ear (Van Gogh), 97
serigraphy, 119
Shakyamuni, 29–33
Shi Huang Di (Emperor of China), 19–22
Shiva (Hindu deity), 60, 61
Shogun, defined, 68
Shogun Ieyasu (statue), 68
Siddhartha (Hindu deity), 30
silhouette, 121–123
silk-screening, 119
Sistine Chapel (Michelangelo), 55–58
slavery, Walker on, 121–123
Sleep of Reason Produces Monsters, The (Goya), 92
Smithsonian Institution, 72
*Spanish conquistadors fighting against central-
 American natives* (De Bry), 65
Spanish Inquisition, 76
Sphinx (Egypt), 8
Starry Night (Van Gogh), 99, 100
Stone Lithography, 110
stupa, 30
Subtlety, or the Marvelous Sugar Baby, A (Walker),
 123
Syndics of the Draper's Guild (Rembrandt), 81

T

Tableaux, 122
Taj Mahal (Agra, India), 37
Temple of the Sun (Tenochtitlan, Mexico), 65
Terracotta Warriors (China), 19–22
Theodosius I (Emperor of Rome), 25
Third of May, 1808 (Goya), 89–92
Tiruchirappalli Rock Fort (Tamil Nadu, India), 61
Tomb of Mausolus (Turkey), 24

Tribunal of the Holy Office of the Inquisition, 76
Trinity College Library (Ireland), 40
trompe l'oeil, 17
Tut (Pharaoh of Egypt), 7

United Nations Educational, Scientific and
 Cultural Organization (UNESCO)
 World Heritage sites
 Buddha at Polonnaruwa (Sri Lanka), 32
 Chartres Cathedral, 43–46
 Cliff of Bandiagara (Dogon art), 72
 Great Wall of China, 20
 Laxcaux caves, 2, 3, 4
United States Capitol (Washington, DC), 14

Van Gogh, Theo, 98
Van Gogh, Vincent, 97–100
van Uylenburch, Saskia, 80
Vauxcelles, Louis, 102
View of Toledo (El Greco), 75, 78
Vishnu (Hindu deity), 61
Vitruvian Man (Leonardo da Vinci), 52
Voyage of Life: Youth, The (Cole), 84

Walker, Kara, 121–123
Wall Mural (Pompeii, Italy), 15–18
wall painting
 Lascaux caves, 1–4
 Roman, 17
Warhol, Andy, 117–119
Water Lilies (Monet), 93–96
Women of Tahiti (Gauguin), 99
World War II
 Kollwitz on, 109–111
 New York School and, 114

Y

Yoshitada, Sanada Yoichi, 69